WHITE CLOUD
WORLDS

PRODUCED BY IGNITE INC.

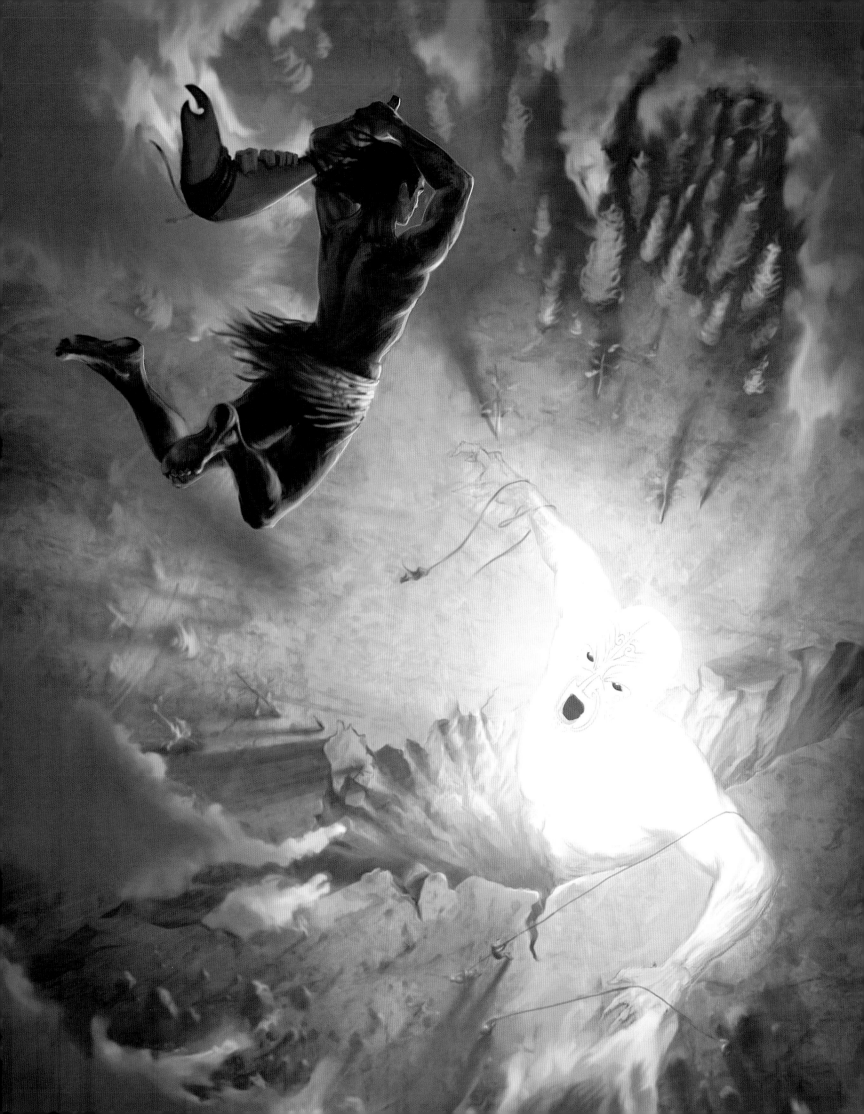

WHITE CLOUD WORLDS

An Anthology of Science Fiction and Fantasy Artwork from Aotearoa New Zealand

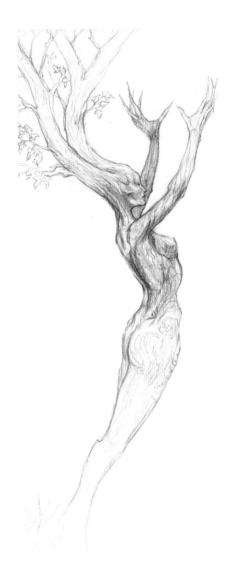

EDITED BY

PAUL TOBIN

HARPER
DESIGN

An Imprint of HarperCollins Publishers

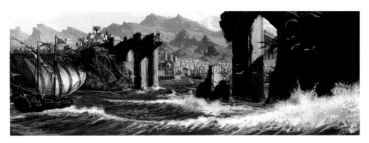

APPROACH TO SASSARINE
Ben Wootten
Paizo Publishing
Photoshop 2007

(Page 2) **MAUI TAMES TE RA**
Matty Rodgers
Digital 2007

(Page 3) **DRYAD**
Paul Tobin
Pencil 2010

ACKNOWLEDGMENTS

It would not have been possible to publish this book without the
inspiration and support of a vast number of people. Thank you.

Firstly, I would like to acknowledge the friendship and guidance
we have received from Lorain Day and the HarperCollins team.
Thank you for taking a chance on this project.

Thanks also to Richard Taylor and Tania Rodger for their
unflinching support of this book and for being such champions
of New Zealand sci-fi and fantasy art.

To all those companies and individuals who have allowed their
works to appear in this publication, thank you for supporting
New Zealand artists and for letting these pieces be reproduced
in our book. We are most grateful to Mike Mignola; Amy Huey
and Darkhorse Comics; Jason Holtman and Valve Corporation;
Merry Luong and CCP Games; Jeremy Cranford and Blizzard
Entertainment; Joseph Goodman and Goodman Games; Shelly
Mazzanoble; Adam Dixon and Wizards of the Coast; Erik Mona
and Paizo Publishing; Chris Smith; the J.R.R Tolkien Estate;
Gustavo Torres and Warner Brothers; Meredith Yayanos and
Coilhouse; Olivier Souille and Galerie Daniel Maghen; DDD
Japan; Plum; ALC Apparel; Minuit; Sticky Pictures; TGS; the
Wellington Art Academy; Illicit Clothing; and Bridget Sloane.

I would also like to thank Guillermo Del Toro, Richard Taylor,
Alan Lee, John Howe, Wayne Barlowe and Christian Gossett
for taking the time to write such wonderful contributions to
this book.

To our friends and colleagues — Ri Streeter, Steve Unwin, Seamus
Kavanagh, Matt Dravitzki, Blake Enting, Gino Acevedo, Stephen
Crowe and David McLaughlin — thank you for always picking
up the phone and for responding to our late-night emails. Your
support has been invaluable. And a special thanks to Amanda
Smart and Kate Jorgensen for really making this book happen.

Finally, the most important 'thank you' goes to all the artists
who have contributed their work to this book. This is an
incredible collection of artwork. I feel honoured to share
these pages with you all.

I would like to dedicate this book to the memory of my father,
Wayne Tobin. We miss you very much.

I hope you enjoy the book.

Paul Tobin

Foreword by

Guillermo Del Toro

Many lands, many tales

It is often said that the great difference between 'high art' and illustration is the fact that the first 'transcends' narrative duties and the second one does not. In other words, an illustration is frowned upon because it is perceived as 'enslaved' by a narrative piece, a story without which it is rendered obsolete. 'High art' then, by contrast, is meant to be free of such worldly preoccupations.

I find, however, that illustration is actually a narrative art by vocation and not by circumstance and, as such, in the best examples, it seems to encapsulate and even pre-empt the literary elements which it is meant to serve. In other words, the image becomes the tale. This is true of the best illustrators of all time: Pyle, Frazetta, St John, Rackham, Tenniel, Quentin Blake, etc. They all become part of the essence of the books they illustrate and, in some cases, seem to reinvent them entirely.

In the case of the artists contained within the pages of this anthology, the images or sculptures seem to actually *be* the tale. There is nothing else needed: no screenplay, no literary piece . . . Each image tells a tale and delineates a land and a time for it to unfold. The images become glimpses into places that have never been or the portraiture of an otherworldly lineage.

The fact that they all come from New Zealand should not be lost on those who have visited this wonderful land. I firmly believe that this is a country blessed with magic and one that inspires its resident artists. Spectacle and drama reside in its kaleidoscopic landscapes, its turbulent and expansive skies and dramatic coastlines.

And, as varied as the land they inhabit is the mind of the artists contained in *White Cloud Worlds*. They will transport you to the uchronisms of a World War One landscape transversed by giant robots, the painful, delicate love story of a centaur and its lady, and the heroics of barbarians and female warriors, amongst many others . . .

These are images to get lost in. To contemplate and speculate about. Malleable and ever-changing, like shape-shifting clouds in alien sky.

Images to dream by.

INTRODUCTION BY
RICHARD TAYLOR

It requires quite a unique combination of skills to be able to close one's eyes, shutting out the world in which we live and everything familiar, and to conceive of an entirely new world with never-before-seen continents, cultures and creatures, and then hold that image as one's eyes open again and recreate it as a dynamic and compelling illustration . . . and to do this on demand and to schedule.

This is the work of the fantasy artist.

Here at Weta Workshop, artists with these abilities are the creative engine that drive our company's output. I have said in the past that we hire the kids who dreamed through math exams and drew monsters on the back of their pencil cases. It seems that to daydream is to fulfil one of the criteria of being a great conceptual designer or illustrator. Paul and Kate have set out to create a book that showcases this most unique talent that is very much alive and thriving in Aotearoa, 'The Land of the Long White Cloud'.

Paul Tobin is an experienced concept designer in his own right and someone I have had the great pleasure of working with for the past five years. As a key member of the Weta Workshop design team, Paul has helped to conceptualize the visuals for many of the films that we've worked on. Joining Paul to drive this beautiful book is Kate Jorgensen, our very adept Design Department Supervisor through the years that Weta worked on *King Kong*, *Tintin*, *Halo* and many others. Together, they've formed a great production partnership and I commend them for what they have accomplished with *White Cloud Worlds*, a book that showcases and celebrates the creativity and skill of New Zealand's fantasy and conceptual artists.

We often get approached by illustrators and painters looking for work in the Weta Workshop design team, and although most demonstrate great skill, it is the ability to think laterally and to conceive and explore original ideas in diverse ways that elevates those who have joined our ensemble. It is the gift of great imagination coupled with exceptional technical illustration skills that makes a great fantasy or concept artist. In the pages of this book, readers will find examples in which the artists have gone beyond simply the creation of a beautiful painting and have embedded a truly unique idea into their art. Many of these artists

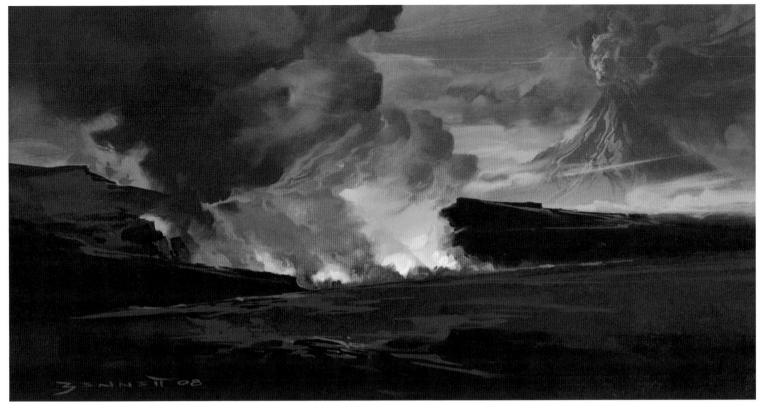

THE PLAIN
Jeremy Bennett
Acrylic on board

have come from backgrounds steeped in traditional illustration techniques, using pencils, oils and acrylic paints. It is the new renaissance of art that has come about with the development of digital communication and computer-based art media such as Photoshop, Painter, Z Brush, and the essential tablet and stylus that has made the prospect of pursuing a career in this field so much more feasible. This unlocks international markets and clients, and has enabled an incredible emergence of talent in New Zealand.

The world is discovering that New Zealand artists have a great deal to offer and that they bring unique sensibilities and perspectives owing to their cultural upbringing in this country. New Zealand has a young culture that is vibrant and energetic. The artists are inspired by the often fantastical environment in which we live, growing up amid natural wonders and ever-changing landscapes and weather, and also draw from the rich art cultures of the Pacific Islands and Aotearoa's own native Maori culture. Certainly, the exposure that projects like *The Lord of the Rings* and *Avatar* have brought the country's creative industries has seen them access clients and open markets that

might previously have seemed out of reach. These clients have found something special in what we offer and the way we express ourselves. It could be said that the country's geographic location, perched at the bottom corner of the world, gives us a unique perspective on things — certainly there is the distinct sensibility that is often expressed in our art and designs.

For over twenty years, I have had the great pleasure of collaborating with many of the artists whose creativity is exhibited in this book. They have imagined and conceived of wonderful new worlds for the films we have worked on together, generating imagery that transports audiences to never-before-seen places. The successful realization and presentation of these worlds is the challenge and ultimately the triumph of the fantasy artist.

The imagination is a great place in which to live and work.

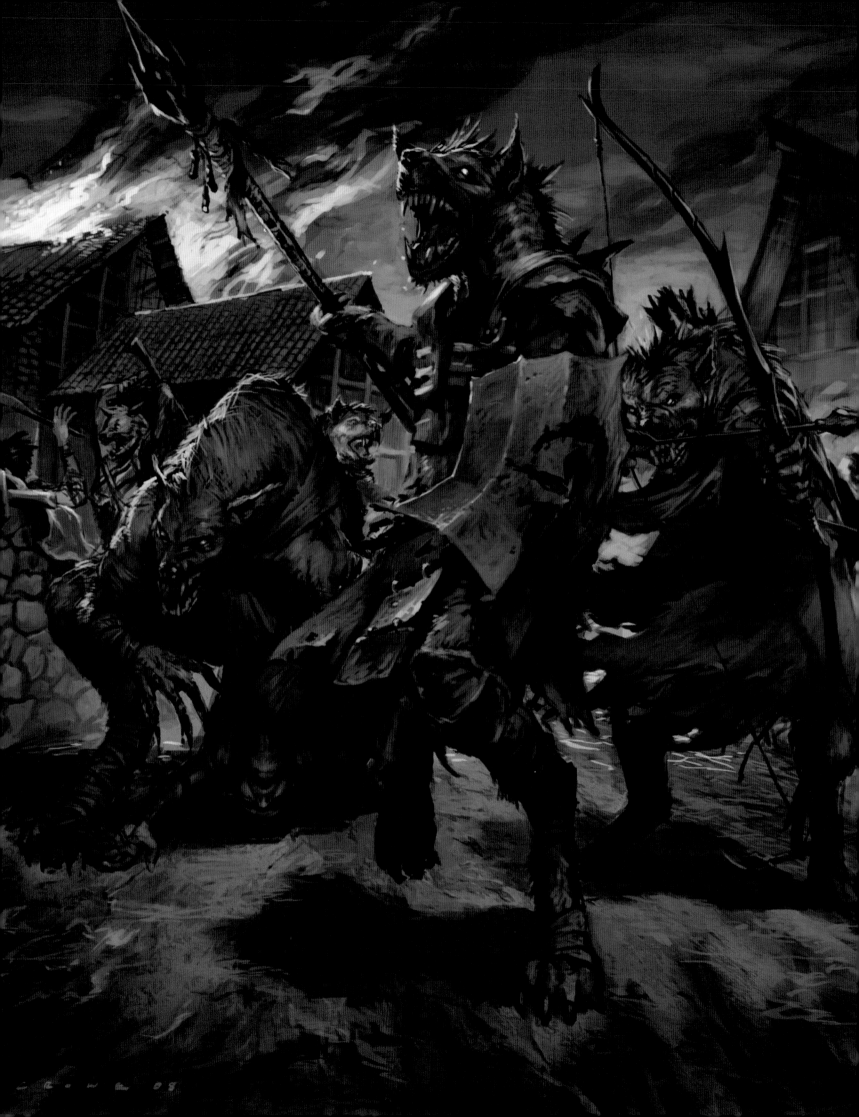

CONTENTS

(previous) GNOLL MARAUDERS
Stephen Crowe
© Wizards of the Coast LLC
Image used with permission
Photoshop 2008

UNTITLED
Nick Keller
Photoshop 2008

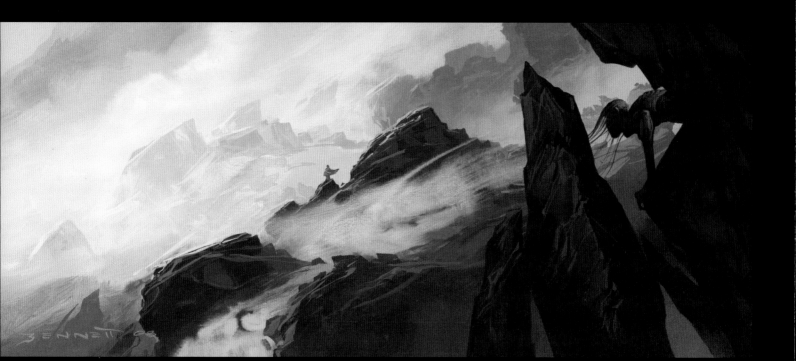

In my spare time I enjoy painting landscapes which are obviously inspired by my work on the trilogy *The Lord of the Rings*. I've found myself pulled back to the world time and again, and while my work references certain portions of *LOTR*, at the same time it reminds me of the fantastic wonders of our own Earth and the very real beauty that can be found on our doorstep.

I was living on the south coast of Wellington while working on the movies and surfing a fair bit when not at work. I knew the coastline well and enjoyed the balance it brought to my life. My solution to the pressure cooker of work was to bring my worlds together, and Mordor gave me the opportunity to do so. Many of the rock and boulder elements in the matte paintings in Mordor were found within a mile or so of my house, and to see the shots years later gives them a resonance that is very satisfying.

For me, conceptualizing shots in Mordor was a double-edged sword. It was an intense time in the production schedule and there was no room for error. It was fairly stressful to say the least, but it seemed that for every problem that needed solving, wonderfully creative solutions were being offered by all involved. The many people who had spent years together helping Peter and Fran craft these films seemed to be running on pure adrenaline and, with the finish line in sight, the task of destroying a small gold ring was not going to stop anyone.

To add to that, it seemed that everybody was carrying the weight of Frodo's quest. It was fitting that our job only became more challenging towards the end. That dark shadow-land therefore came to symbolize everybody's struggle and is one I certainly still focus on in my work.

To sit and paint these forms again and to contemplate palettes or compositions that weren't used is a nice way to drift back and relive a special time. Painting, I believe, should be infused with skill, memory and a desire to share experience, and this is my humble attempt to capture those qualities.

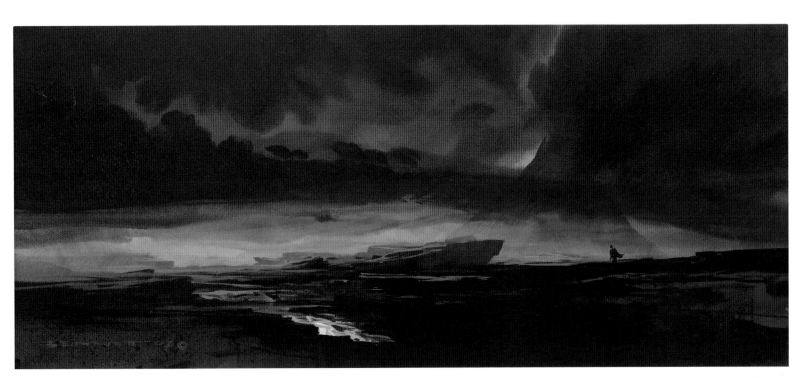

Shadow Lands
Acrylic on board

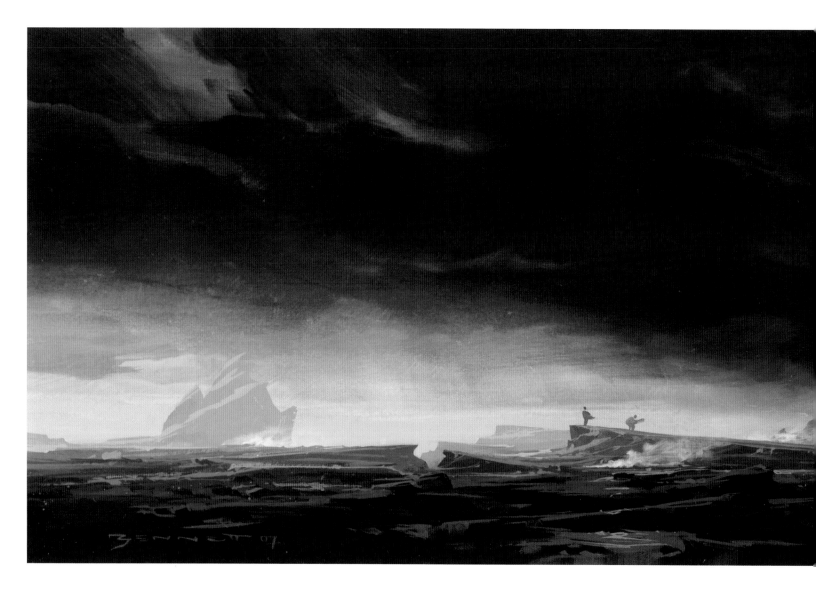

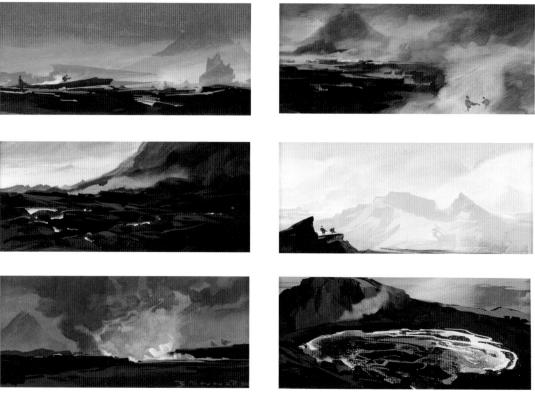

COLOUR KEY 01
Acrylic on board

JEREMY BENNETT

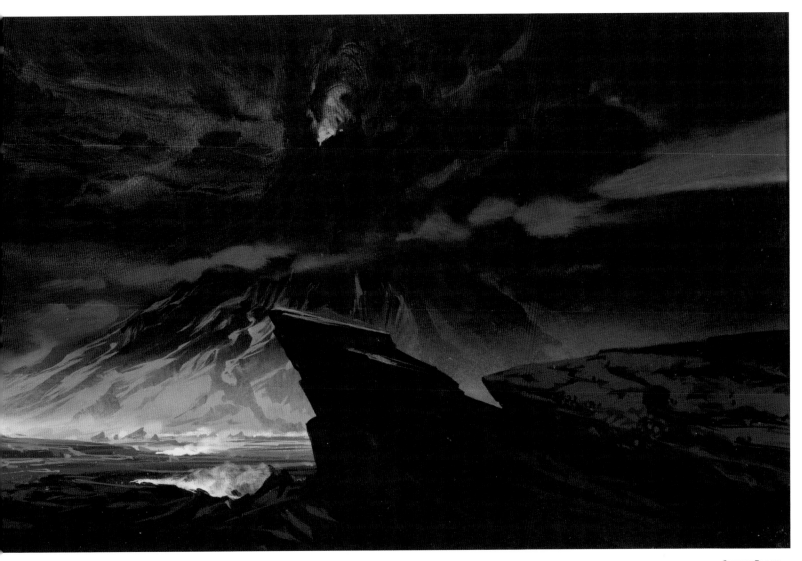

ON THE PLAIN
Acrylic on board

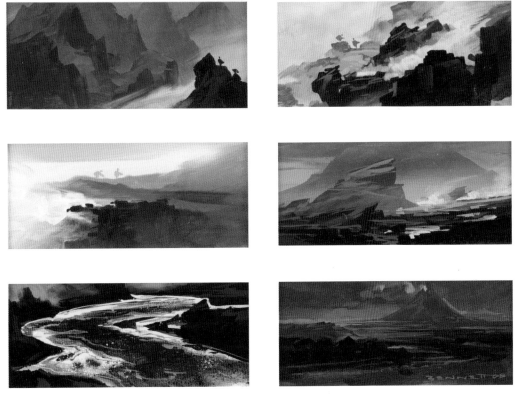

COLOUR KEY 02
Acrylic on board

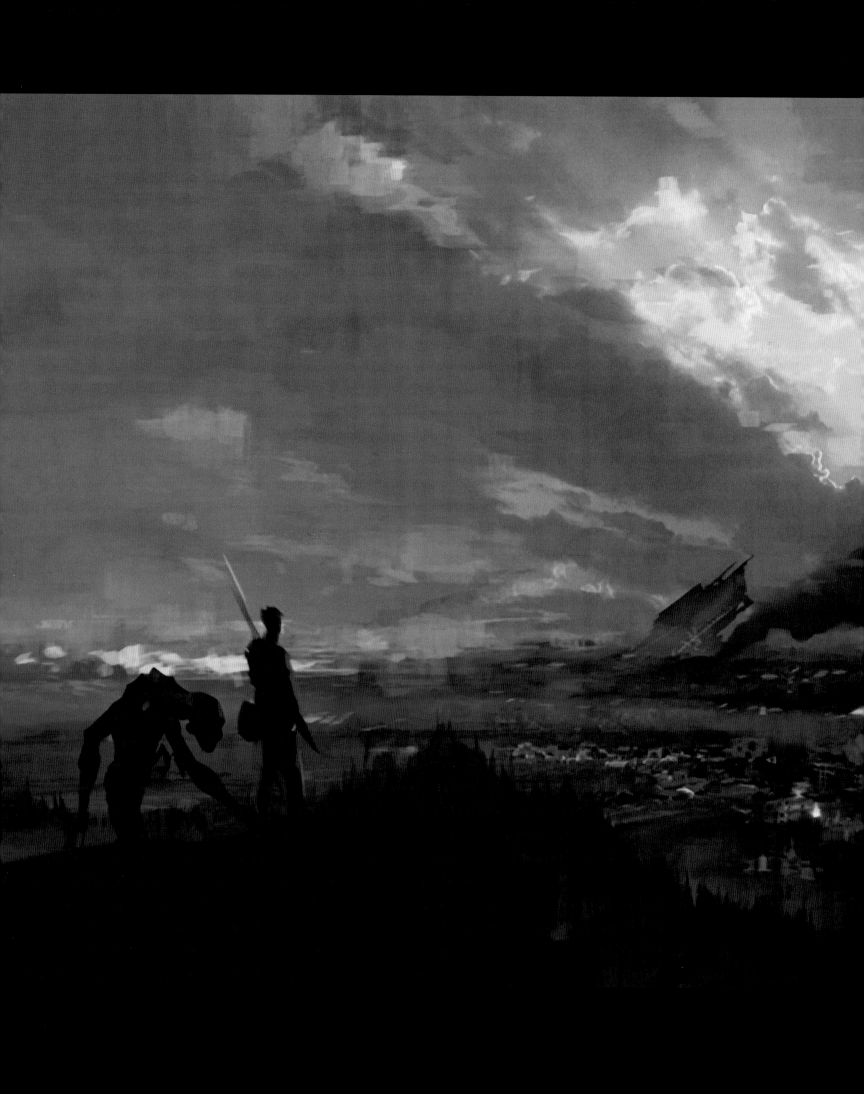

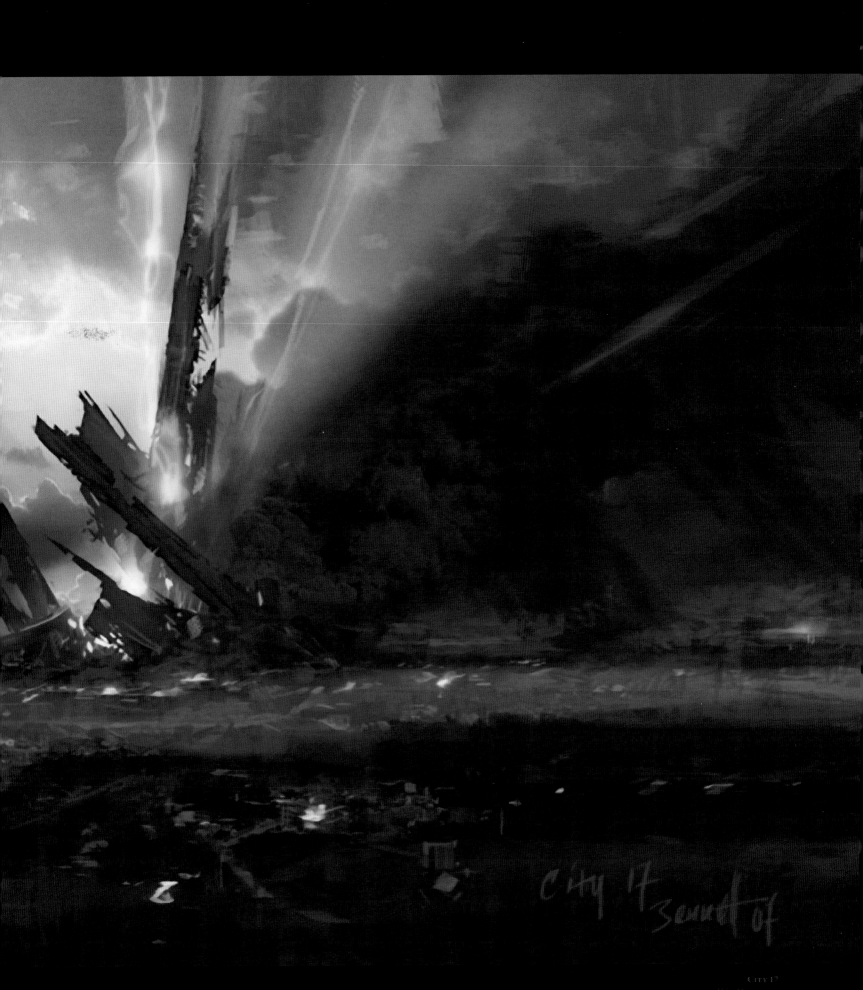

City 17
3 sunset of

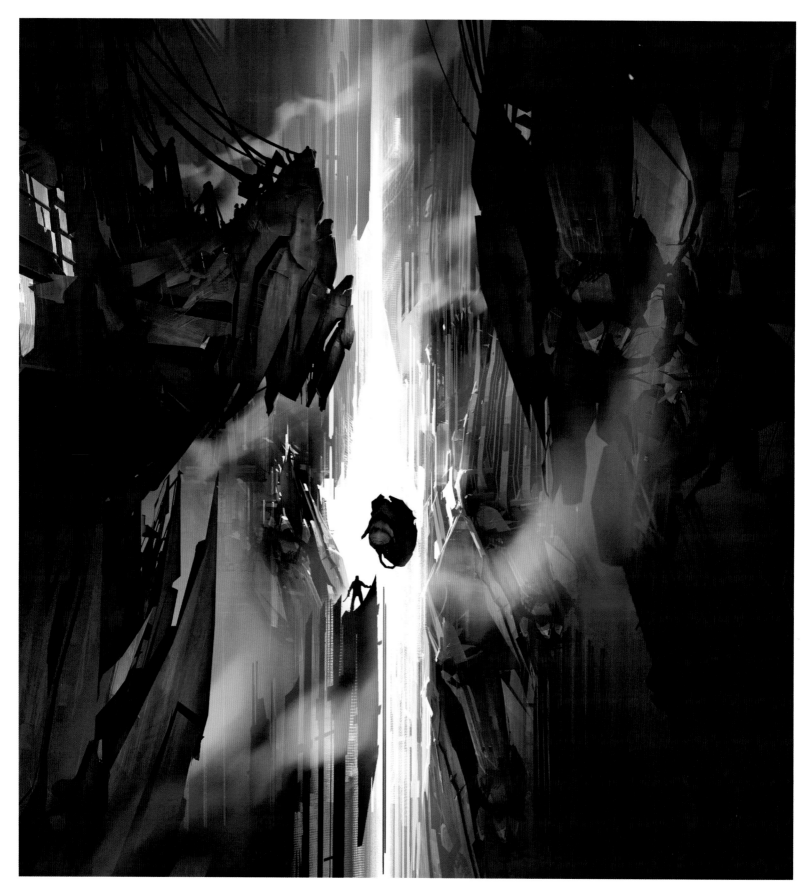

JEREMY BENNETT

GUS HUNTER

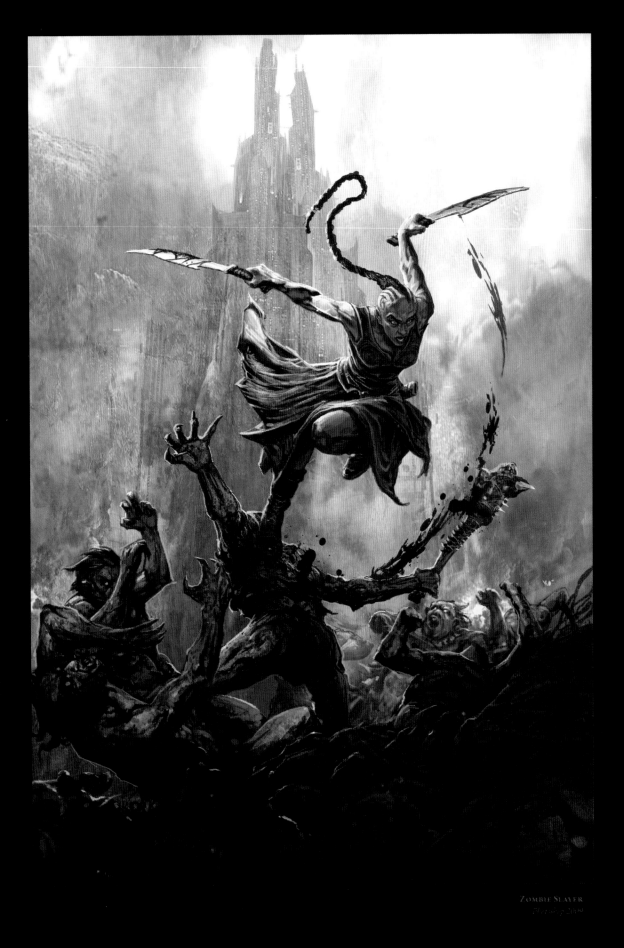

My interest in art, I think, goes back to a very early age. My parents emigrated from Samoa to New Zealand in the 1950s, eventually settling in Porirua. They had a hard time bringing up six sons (I'm the youngest) at that time.

We didn't have many toys to play with, so we made our own from bits and pieces that we found, and we also drew a lot to pass the time. Meanwhile, I was exposed to many different styles of art from the Western world in the form of films such as *Animal Farm*, *Disney* animated feature films that I watched on TV, and comics like *Marvel*, *DC* and *Creepy* that sparked my interest in art during those young years.

I was also inspired by old master painters like Michelangelo and Leonardo Da Vinci whose drawings and paintings showed the true form of the human body. When I was about twelve I used to get out a whole heap of books about them from the public library, go home and copy their drawings, sculptures and paintings like crazy! There was just something in the way that they drew the human anatomy that really inspired me at that time, and they still do today.

Modern-day influences have been fantasy illustrators like Frank Frazetta and, just recently, through the film industry, Craig Mullins, John Howe and Alan Lee; while graphic comic influences have come from Richard Corben, Bernie Wrightson, Dave McKean, Alex Ross, Simon Bisley and Moebius.

Before working as an illustrator, I worked in the public sector, for the Ministry of Internal Affairs. After four years of pushing a pen in an office I made the decision that the job definitely wasn't me, but, more importantly, it was at that point I realized what I really wanted to do. So I suddenly left my job — much to my dad's dismay — and started a journey towards anything to do with art.

This eventually included going back to study and completing a three-year diploma in Visual Communication and Design at Wellington Polytechnic. After graduating from there I started working freelance and did various jobs for a number of government departments, graphic design companies, advertising agencies and publishing firms like Learning Media.

I tried to broaden my illustration style to suit cartoon, caricature, storyboard, semi-realistic to realistic in order to be a more

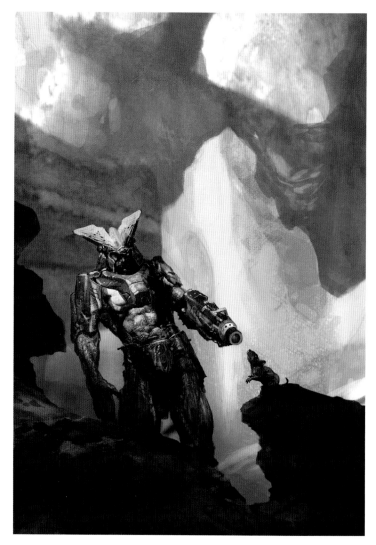

ALIEN INVADER
Photoshop 2009

versatile illustrator. I also became involved in facilitating illustration workshops around the Pacific Islands through NZAID, teaching local budding Pacific artists to illustrate local stories for children's books. For me, as I am of Pacific Island heritage, being able to give something back to the Pacific community brings a lot of satisfaction and enjoyment.

In 2000 I started working in the film industry and having worked on numerous feature films as a concept designer, I have had the privilege of meeting and working with a number of exceptionally talented artists and directors along the way — not to mention the talented bunch of people who work at Weta Workshop. Their creation of design, props, costumes, miniatures and make-up is an inspiration to all. It's a very creative environment to be in, sometimes very intensely challenging but rewarding when you see the final product on the big screen.

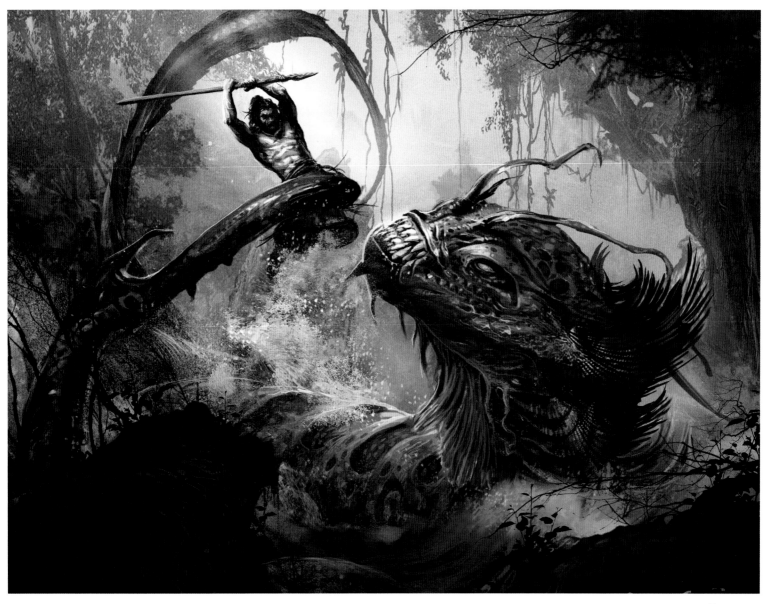

TANIWHA
Photoshop 2009

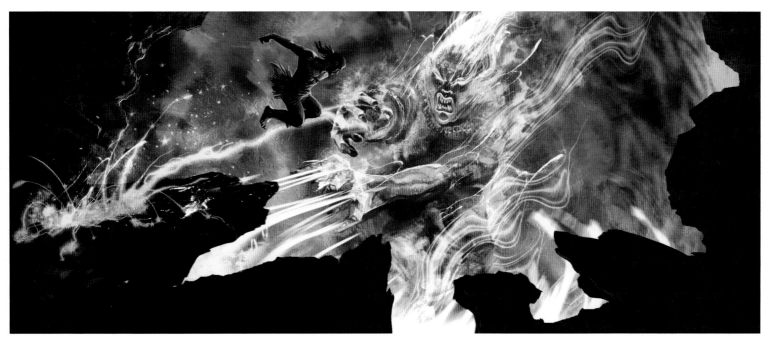

MAUI AND THE FIRE GOD
Photoshop 2009

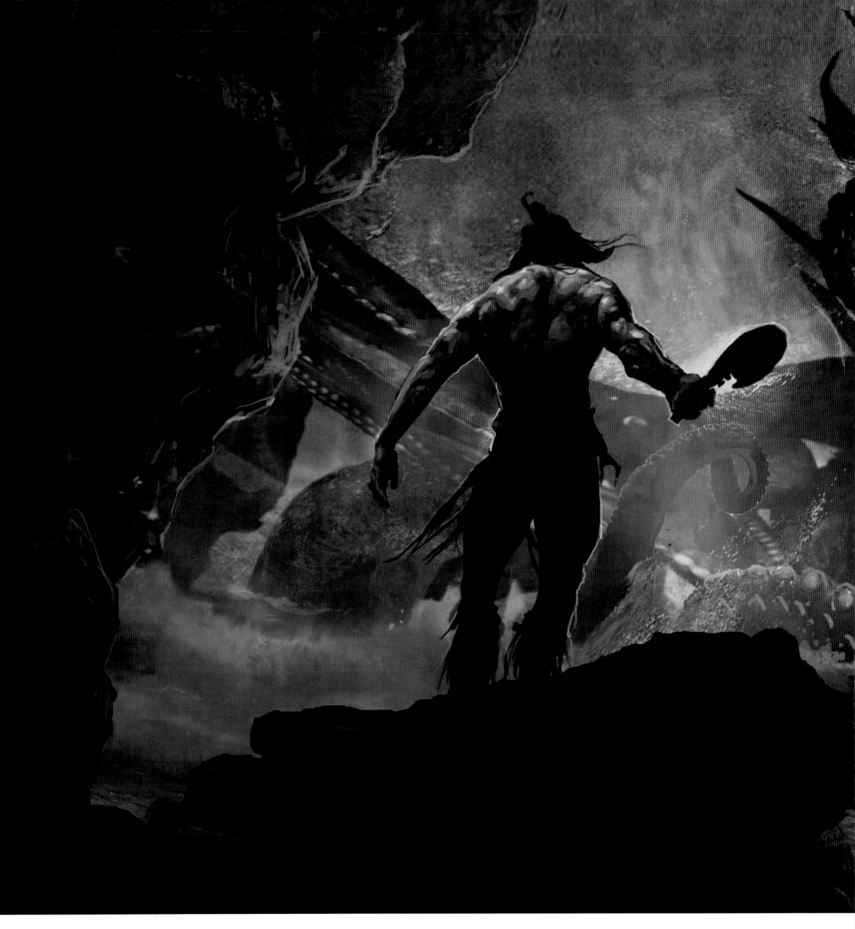

My way forward is to continue to develop my style as an artist. And as I believe that life is one big continual learning curve, I feel that I have quite a way to go yet.

Some of the pieces reflect some of the very interesting myths and legends from this beautiful land of ours, a land where I was born and grew up . . . Aotearoa, The Land of the Long White Cloud.

GUS HUNTER

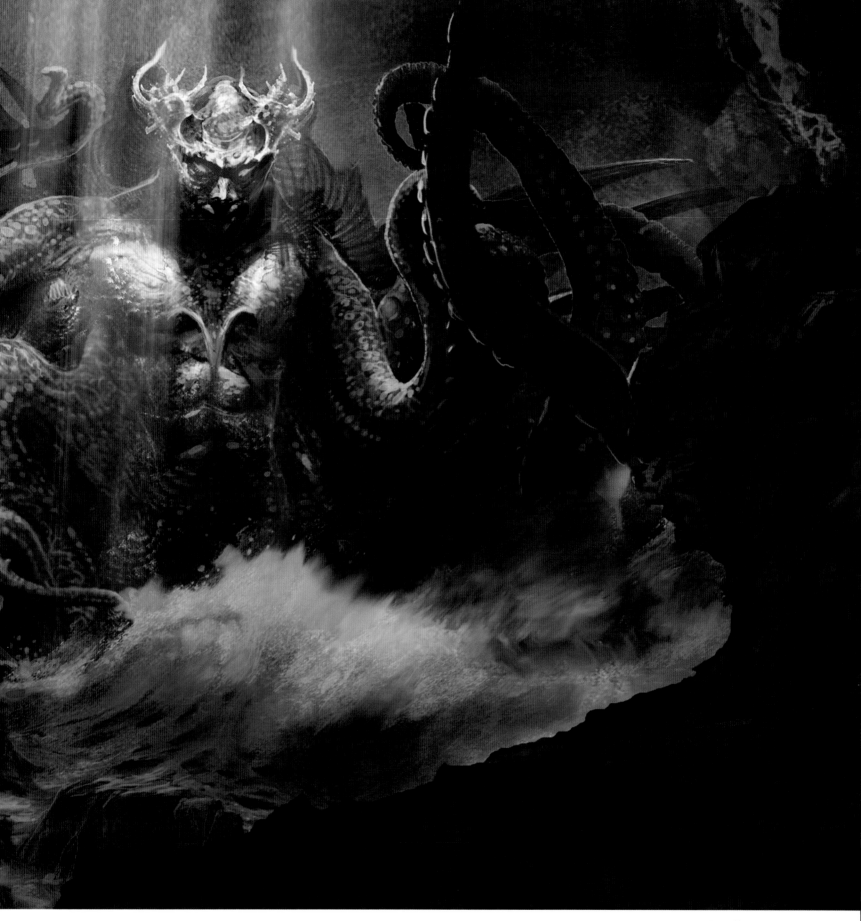

Kupe Faces Te Wheke
Photoshop 2009

JEFFREY LAI

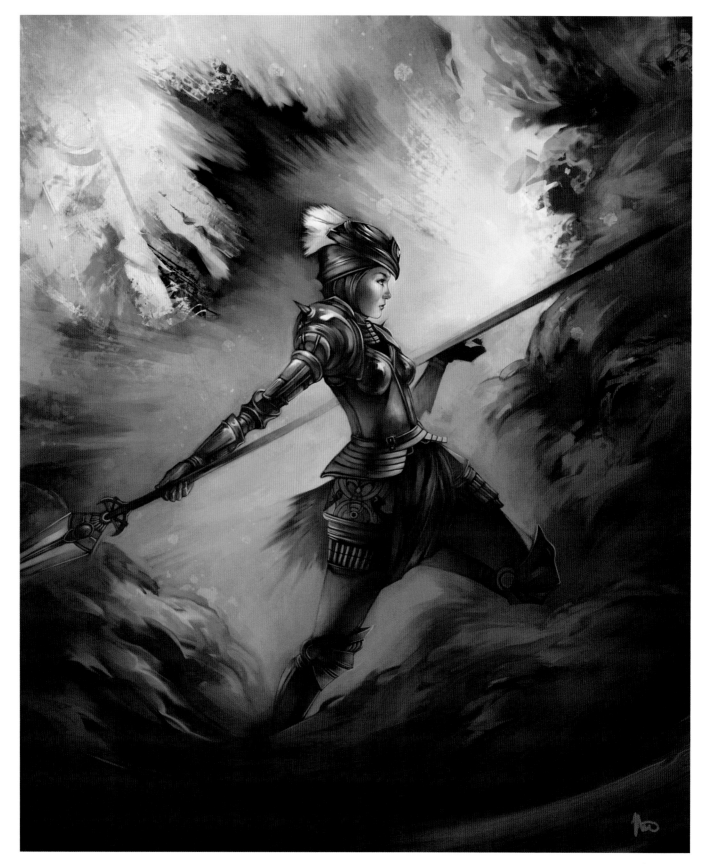

ASSASSIN
Photoshop 2008

I have this art zombie always following me around, holding me to ransom, reminding me to practise or be eaten! My inspiration! I think inspiration comes to you when you're not really thinking about it my inspiration can come from all sorts of different places, such as animation, photography, classical paintings and reading about animals.

To be honest I am not really sure how I got into art; I just fell into it. Taking art classes during my school years was the only thing I was really interested in — I couldn't do math to save my life!

I started doing digital art when I was at university, where Paul Tobin showed me the wonders of a tablet. I like to draw and paint fantasy-themed illustrations, but I often find myself returning to nature. Bugs, animals and the natural world seem to intrigue me the most. I find the way animals have evolved to suit their environment amazing, which is probably why I like to paint forests and make up the creatures and the societies that inhabit them, although zombies will always have a special place in my heart too. They are just so much fun to draw.

When I begin a piece of art I usually start off really gesturally and try to let it flow out. Forcing it leads to unpleasant results, so I try not to get too attached to the beginning stages. After a large amount of scribbling I begin to see things and an image pops out and I begin to develop it from there.

One thing that seems to remain constant with all artists is the need to work hard! Draw and paint like there is no tomorrow!

www.jeffreylai.deviantart.com
www.jeffrey-lai.blogspot.com
jefflaiart@gmail.com

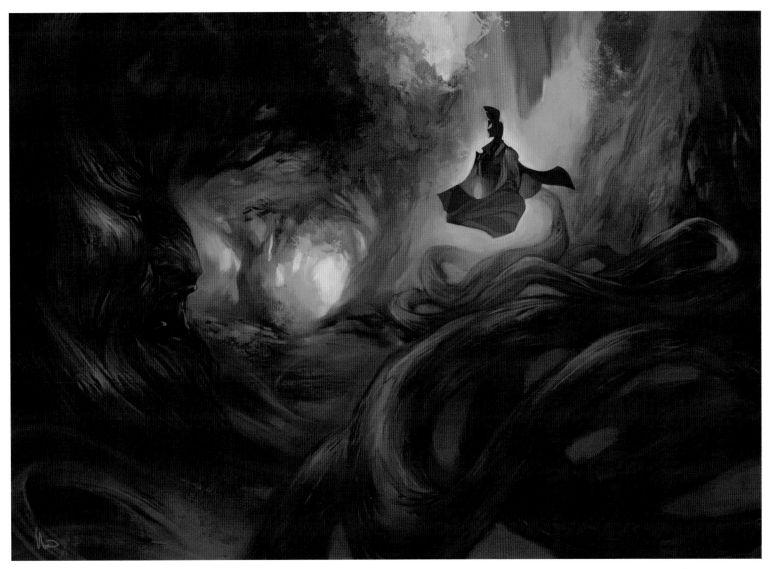

ENLIGHTENMENT
Photoshop 2009

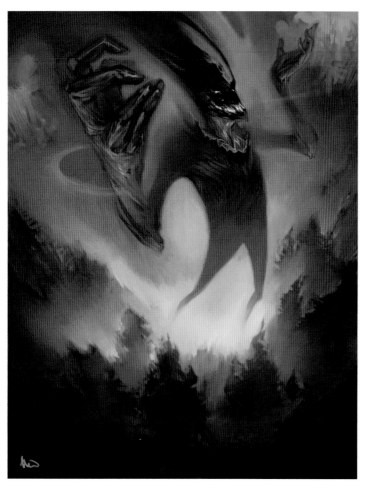

FIRE ELEMENTAL
Photoshop 2009

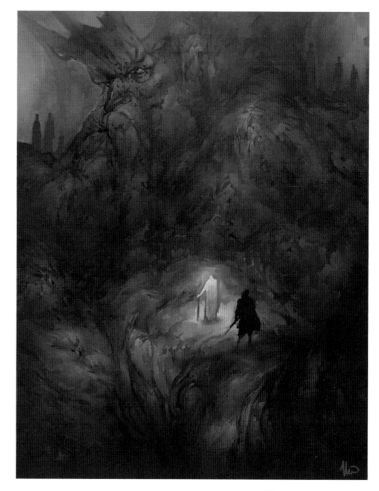

HEART OF THE FOREST
Painter 2009

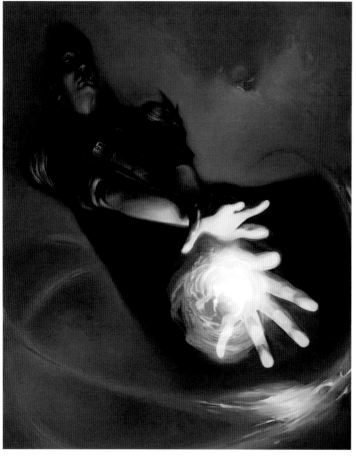

FIREBALL
Photoshop 2009

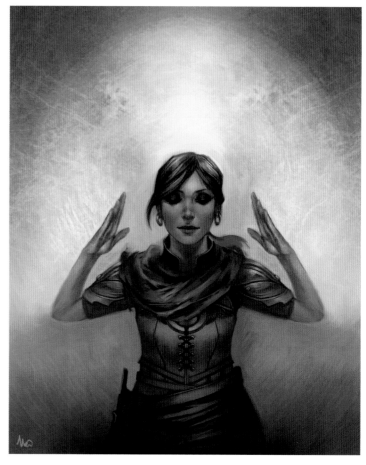

BRILLIANT AURA
Photoshop 2009

JEFFREY LAI

GUIDO ANTON

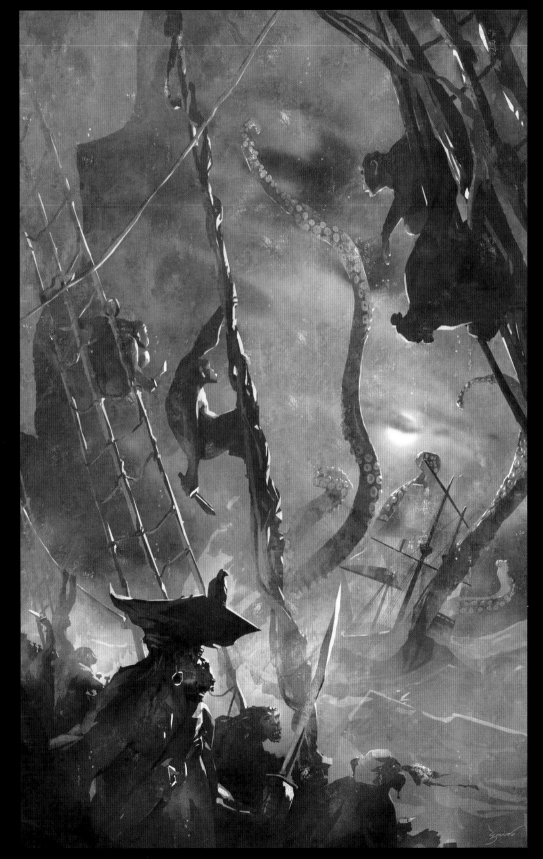

CHIMP PIRATES
Photoshop 2008

I'm a full-time artist keeping busy with a variety of personal and collaborative projects with people I share an affinity with. I tend to think big picture, and plan with creative freedom to keep enjoying, experimenting and sharing my work.

'Chimp Pirates' is a piece that flowed easily from concept to creation. It was a vision I saw clearly in my mind, a fantastic adventure. I strive for a stylized realism in all visual areas, always searching to communicate mood and narrative. I worked with a hard brush and eraser, alternating to carve out shapes to create visual interest and design. I found it was a great way of communicating ideas broadly and accenting with necessary details.

In 'Beast and Beauty' I looked to capture a moment between characters of opposing worlds, focusing on narrative and internal dialogue. The Beast's inner battle to find love, the Beauty's search for the man within the beast. There is a realness in juxtaposing beauty and darkness within art that I enjoy.

'Story Time Pumpkin' has found me playing around with traditional media again. I feel a regression back to my inner child and a reconnection with what first sparked my art appreciation in picture books and fairy tales. It's a magical realism, a reflection of my life and how I'm seeing the world.

I find my creative path always evolving and surprising. I'm open to changing plans and new interests. I find ideas always come back full circle and manifest when the time is right. It is a level of faith and self-belief that keeps me creating, and I find it easier to flow with change than to resist it. Art isn't just about developing a skill set to fulfil a requirement. I acknowledge the values I gain through creating art and carry them over into my life.

www.guidoanton.com, itsguido@gmail.com

STORY TIME PUMPKIN
Pencil 2009

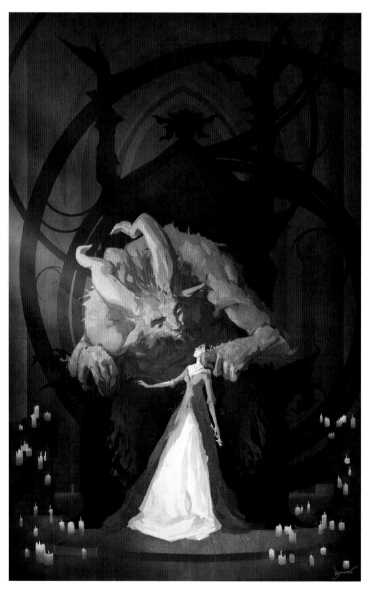
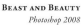

BEAST AND BEAUTY
Photoshop 2008

BEN WOOTTEN

NEARLY GOT IT
In Search of Adventure cover
© Goodman Games
Photoshop 2009

My earliest memory of drawing was in green crayon on a cardboard box. Now what would a five-year-old child be drawing? Oh, of course, duck hunting — well, duck hunting in fighter planes. Seems a little unfair on the ducks, looking back, but the planes got the job done.

From duck hunting in aeroplanes the theme continues: hot-rod planes and war scenes drawn with my early childhood friend Warren Mahy (see the sad old scribbler of the same name in this very book). Then, with the discovery of Dungeons and Dragons at the age of twelve, the world of fantasy opened before me, including my first reading of *The Lord of the Rings*. Endless hours were spent playing games and drawing the heroes and monsters found in there. To say this was an obsession of my early teenage years would not be too far from the truth, this prompting the often-heard query from Mum, 'Why can't you draw something nice, something like flowers or birds or . . . ?' Well, needless to say, these helpful suggestions were rarely acted upon.

A conflict of interest occurred as my schooling progressed. Science or art, which way to go? The answer was of course . . . science! What? Why? Easy to explain really, there were more opportunities for work in the various fields of science, but mainly because it was easier to get good grades in and I was definitely one for the path of least resistance at that age.

Science at school, leading to a zoology degree at the University of Otago, then . . . then? After seven or eight years of science I discovered it was 'not really what I wanted to be doing'. A rethink was in order now that I wasn't going to become the next Jacques Cousteau or David Attenborough and certainly not a science teacher (nearly happened, terrifying). But wait — what about art? My drawing had continued as a hobby; I was still drawing characters and creatures to support my continued love of fantasy games. This led me to a course in design/illustration in Christchurch, and eventually meeting Jamie Beswarick. Jamie introduced me to sculpting and then to Weta Workshop, this fateful meeting making the uncompleted art course seem less important in the grand scheme of things . . . should really tell my folks about not finishing that!

I worked at Weta Workshop for ten years as a sculptor and designer. The very strange world we live in found me again drawing heroes and monsters alongside Warren Mahy, working with so many talented and fantastic people. Not to mention

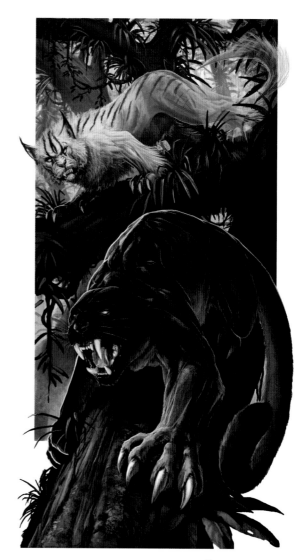

PANTHERS
Monster Manual 4th edition © Wizards of the Coast LLC
Image used with permission
Photoshop 2009

working on amazing projects, including what had been my earliest introduction to fantasy literature, *The Lord of the Rings* — what a crazy world we live in. I got to work with the likes of John Howe and Alan Lee, I got to sculpt Balrog and meet wizards, real and imagined. I learned so much on my wild journey through the world of film design. I learned from John Howe how armour works and about sword fighting. How to sculpt make-ups for orcs and populate strange new worlds with creatures and characters both familiar and those never seen before. And, amazingly, the years spent studying zoology and science were not the waste I would have thought, but there to lend a hand in the form of knowledge of anatomy and behaviour. How does that creature move? Why does it look that way, where does it live and, most importantly, who does it eat?

I visited the land of Narnia, met Aslan, ran from King Kong through the jungles of Skull Island, and saw many other strange sights too numerous to mention here.

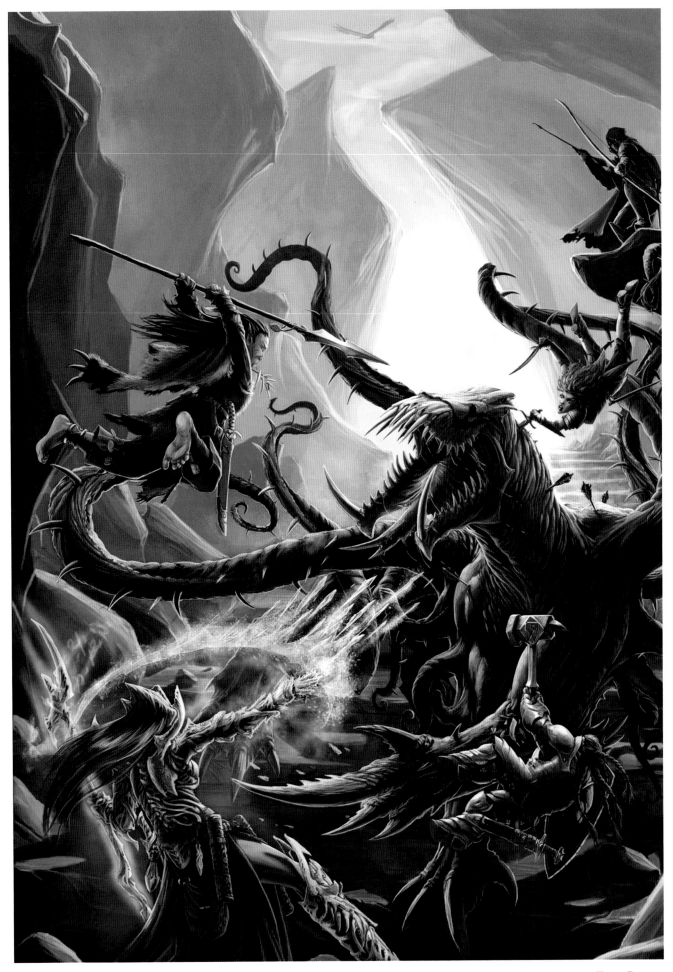

TOUGH FIGHT
Players' guide cover *Ramlar*
Whitesilver Games
Photoshop 2009

BEN WOOTTEN

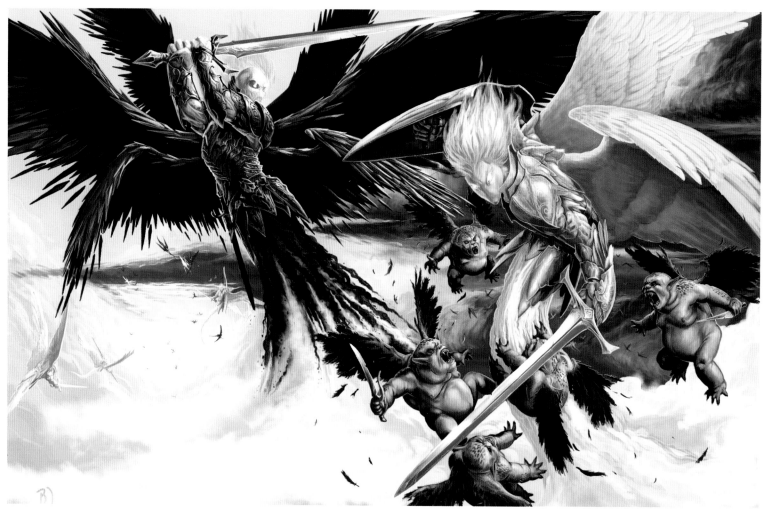

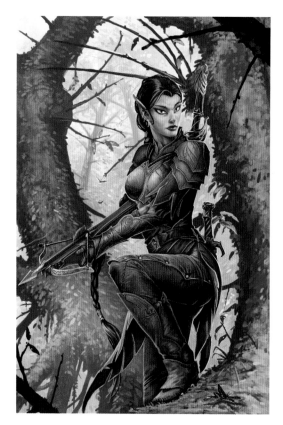

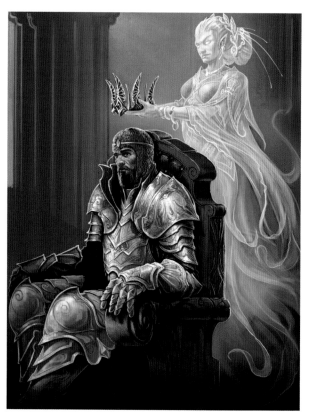

BEN WOOTTEN

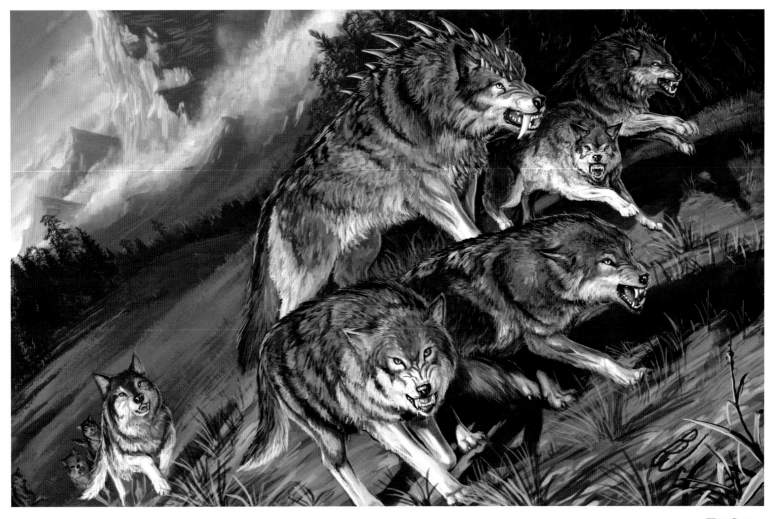

WOLF PACK
Pathfinder Roleplaying Game Bestiary © Paizo Publishing
Photoshop 2009

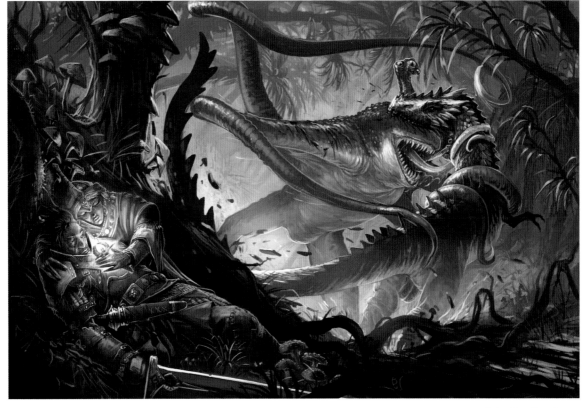

LET'S SIT THIS ONE OUT
© Paizo Publishing 2009
Photoshop 2009

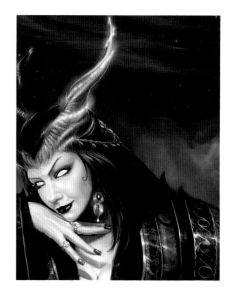

THIEF, PALADIN AND WARLOCK
© Goodman Games
Photoshop 2009

Where I am now? In a dark place, in the deepest recesses of a house in Miramar, Wellington, New Zealand, hunched over a Wacom tablet in the pale light of a computer screen I sit. I sit and draw. Knights, dragons, wizards and rangers. Elves in green woods, flying ships coursing the skies of strange worlds. Thieves and treasure, angels and demons. Spacecraft racing between far-off star systems, aliens and robots. I am paid to relive my childhood every day; life is very strange and I am very lucky.

'Why can't you draw something nice?' Words to live by.

www.benwootten.com

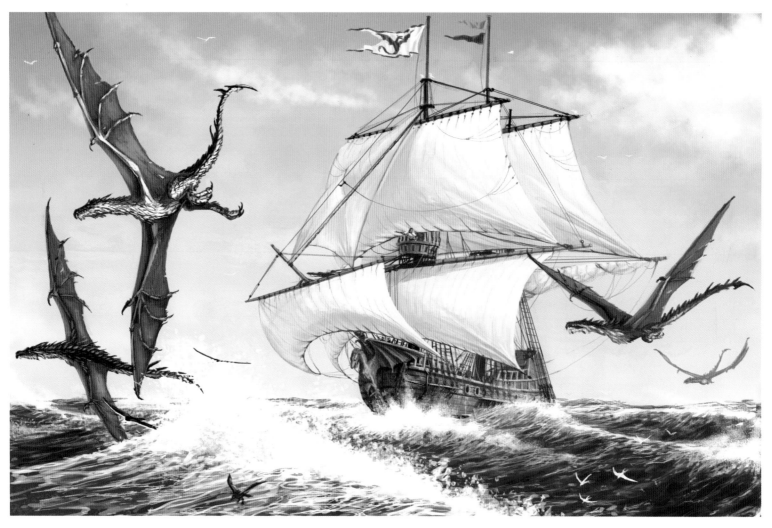

SEA WYVERN REACHING
© Paizo Publishing
Photoshop 2007

BEN WOOTTEN

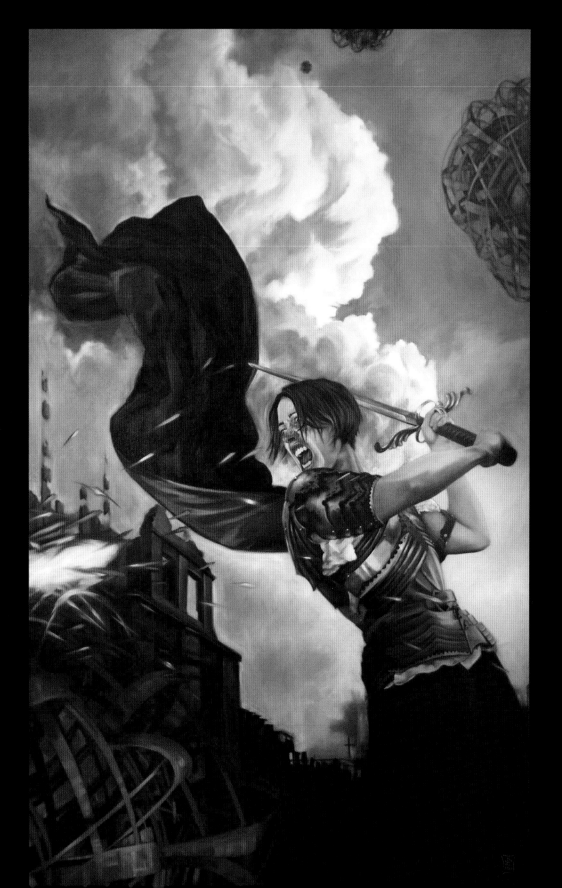

I have always created. I simply don't know any other way of being.

Through the eyes of a parent, having their sweet little girl opting to draw horse carcasses amongst swamplands, rather than the orthodox pretty pink petals of a flower must have seemed like a morbid obsession.

I recall my mother often putting dinner on top of my drawing to encourage me to stop and eat. It's a lovely place to be, completely submerged in creation — left to wonder and play in your own imagination. The feeling is still very much the same today and I easily lose track of time. However, the realities of being a commercial artist rarely allow me the freedom that I knew as a child.

Early on I loved the surrealists and was totally enthralled by Salvador Dali. Today I am inspired by the great art masters, especially the Flemish painters. My inspiration is certainly not limited to the visual. Music is also very powerful. I find that listening to music composed in the minor key inspires me to produce my most passionate work.

I enjoy creating in many genres and certainly don't limit myself in terms of media or tools. However, I find that oil painting is what I am most passionate about. I am captivated by its translucent quality and luxuriance. These qualities embody what I aim to achieve in my artworks. Ultimately I want my painting to visually sing.

The longevity of oils brings an air of mystery. Works from the past open a window from another time and world. I wish that the works that I create will continue in this tradition to be enjoyed by future generations. This is what I tell people, but like all artists what I really want is to achieve immortality through my creations.

A successful painting in my eyes is one which tells a story, takes you on a journey and evokes an emotional response. It excites me that an artwork can express different things to different people depending on their perception, background and experiences.

Art is a journey, not a destination. I believe painting requires a lifetime to master and I expect to be creating my best works well into my eighties.

www.sachalees.com, sacha@sachalees.com

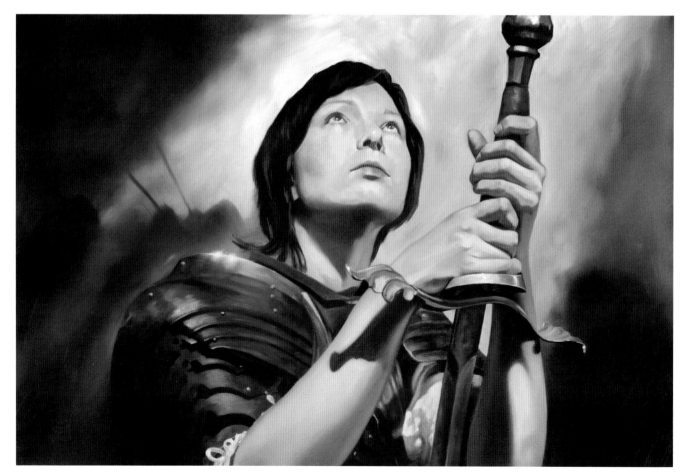

VALOUR
Oil on canvas 30" x 20" 2007

SACHA LEES

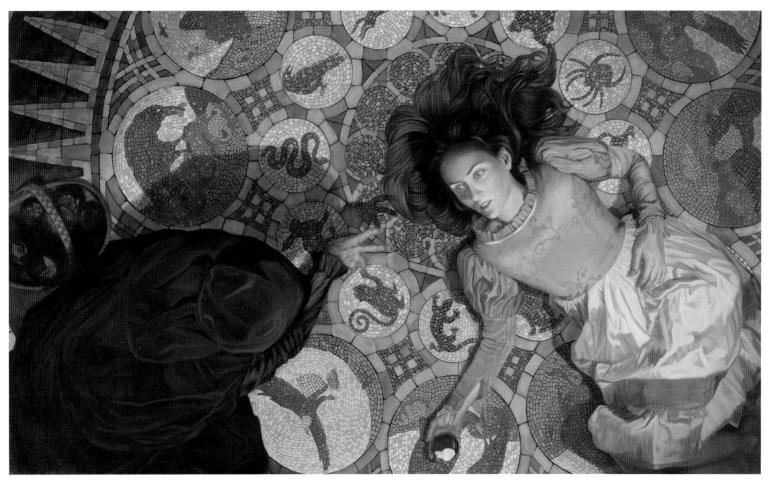

MALUS DOMESTICA
Sloane Collection
Oil on canvas 60" x 36" 2010

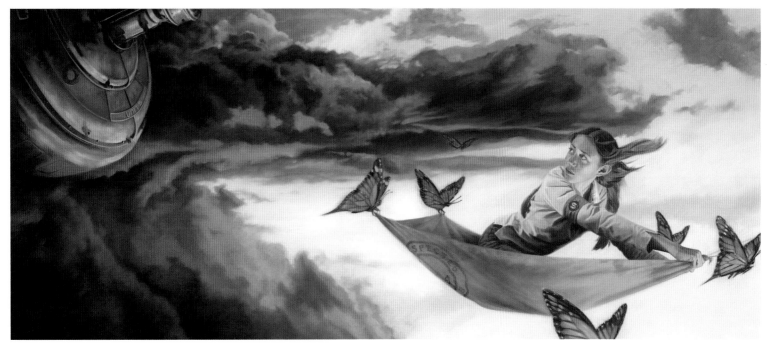

UNIT 5
Sloane Collection
Oil on canvas 59" x 25" 2007

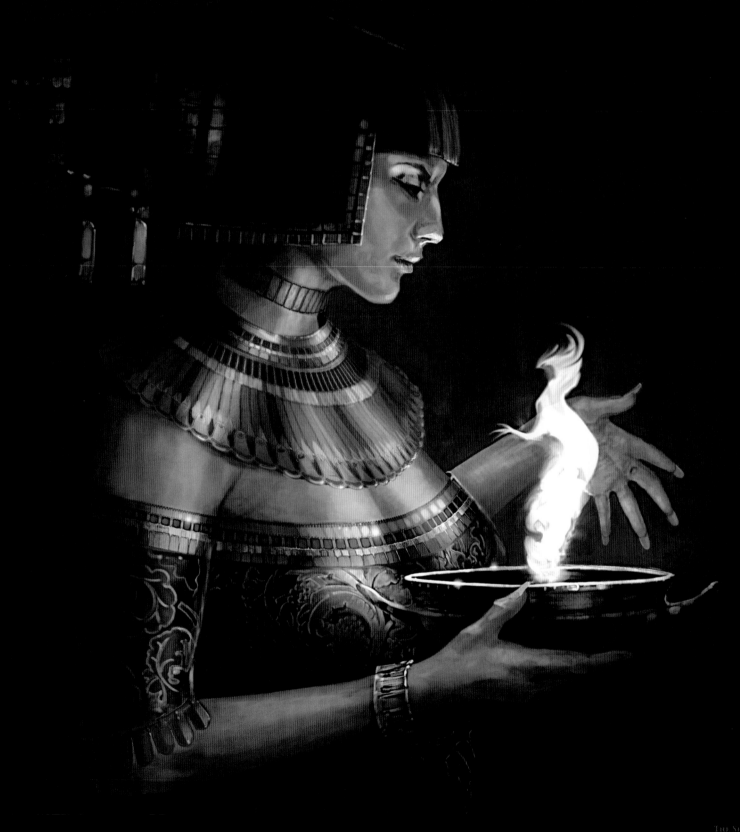

Midnight has been and gone and it's well into the a.m. It's that quiet time, when most artists actually get some serious work done as the distractions drop off and the next cup of coffee kicks in. For some of us, this is the time we scrimp and save for ourselves to labour over our own projects. Many sensible artists will be mashing PlayStation controller buttons; some will spend their time in other constructive pursuits (like sleeping). But for a few of us, there is a certain, undeniable compulsion to create worlds of our own imaginings, free of the confines imposed by client briefs and budgets. These imaginings evolve, not surprisingly, from our own interests and experiences, and are often coloured, at least initially, by creative influences — many of which made strong impressions upon us in our formative years.

My major influences are easy to recall: the thrill of watching *Indiana Jones* for the first time, firing my sense of adventure — which set me upon a path of exotic travel, studying ancient history and a brief foray into archaeology. A teenage birthday present of *Merlin's Dreams* by Peter Dickinson, illustrated by Alan Lee, sparked a lifetime of interest in illustrating myths and fairy tales. And finally Jim Henson, whose magic and imagination inspired so many of us now working in fantasy film making.

Leap to 2008, and I am sitting on a plane halfway to Israel on a research trip with fellow Weta designer Gus Hunter. As I peer out of the window into the dawn haze, a scattering of steep fairy-tale-like islands — precursors to Hong Kong — materializes magically out of the dawn and my mind turns to a reoccurring interest — Atlantis. With another eighteen hours of the trip to go, there was never a better time to finally get my version of Atlantis down on paper. Now, a couple of years later, the notes and doodles have evolved into an array of characters and a story of high adventure. Whether it is a book, a film or even a computer game, or merely a bit of fun, is yet to be seen. Like Atlantis it, too, is still shrouded in secrecy, but at its heart is a simple premise: that Atlantis survived its cataclysm, but was cast apart from the world it once dominated. After thousands of years of tyranny by the ruling exotic race and cultural stagnation, a change is heralded when the first doomed crews of numerous Atlantic crossings are cast upon its broken shores. As a result of the intermittent and — so far — one-way connection back to our world, Atlantis undergoes a renaissance

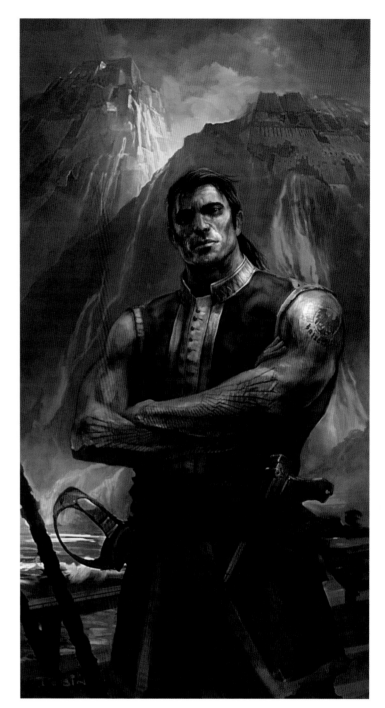

DER KAPITÄN
Photoshop 2010

influenced by the tantalizing developments of our own world. It is a divergent cultural evolution that embraces some elements of technology and progress but shuns others. It is a paradoxical land of wonders that until now has been apart from our own world conflicts. However, that is about to change . . .

www.paultobin.co.nz

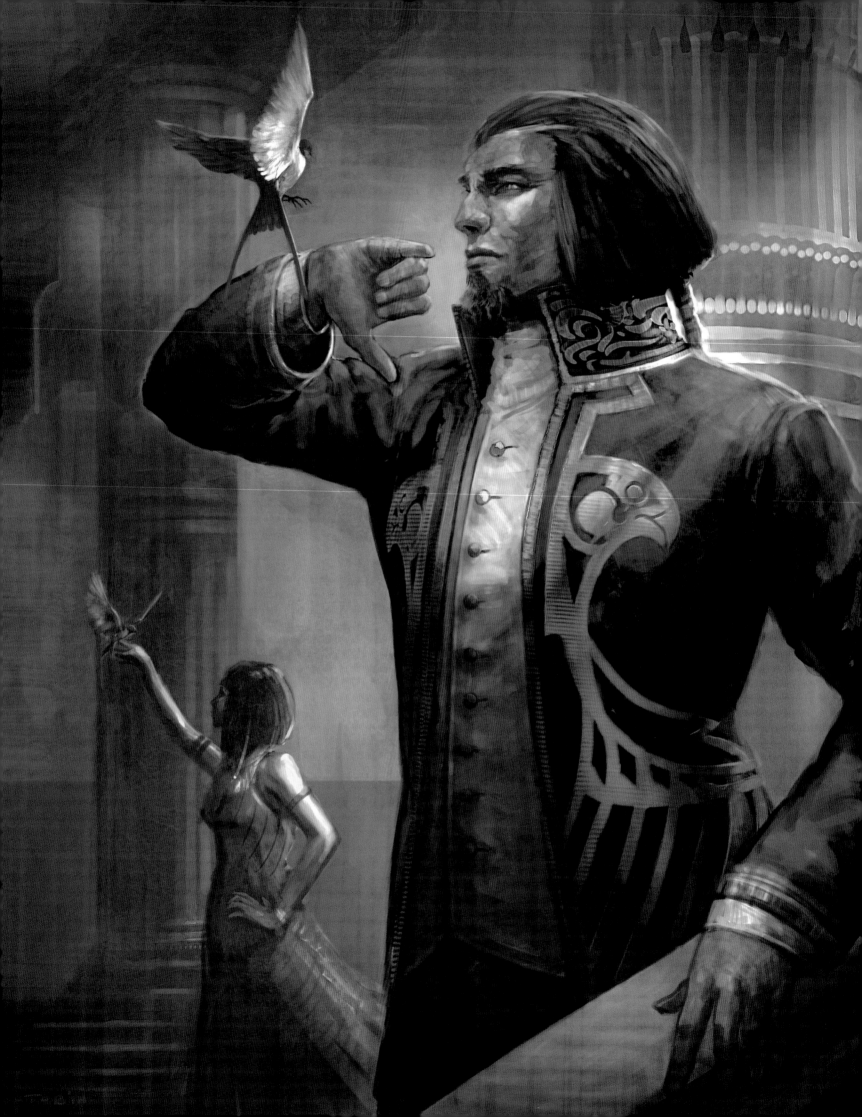

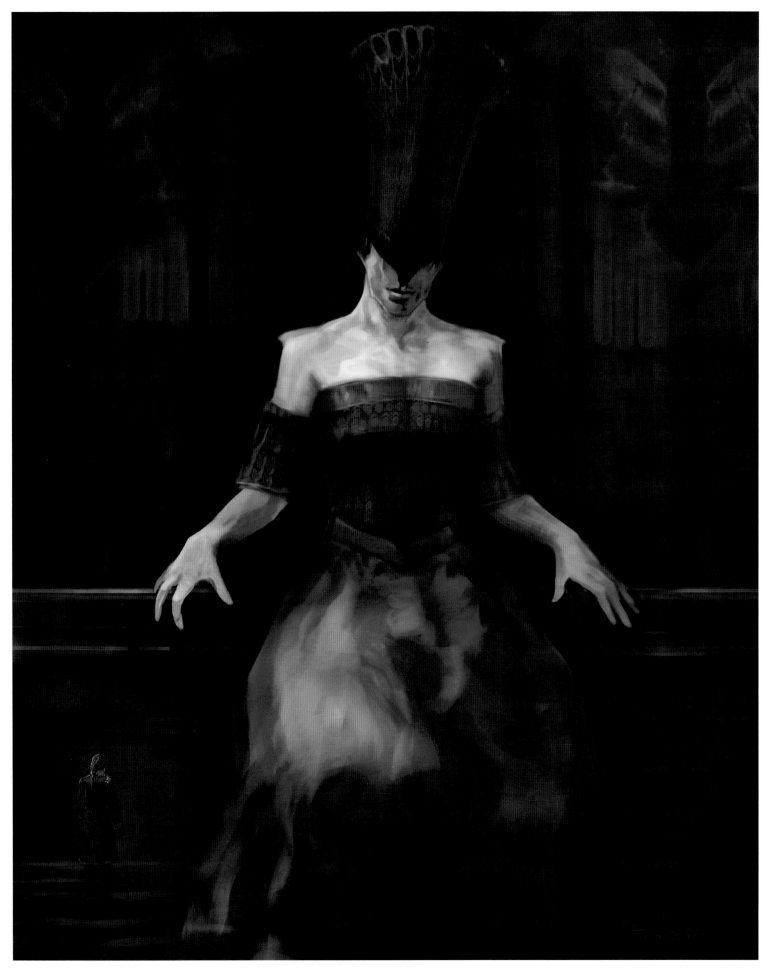

(previous) **MESSENGER**
Photoshop 2010

ENNEAD
Photoshop 2010

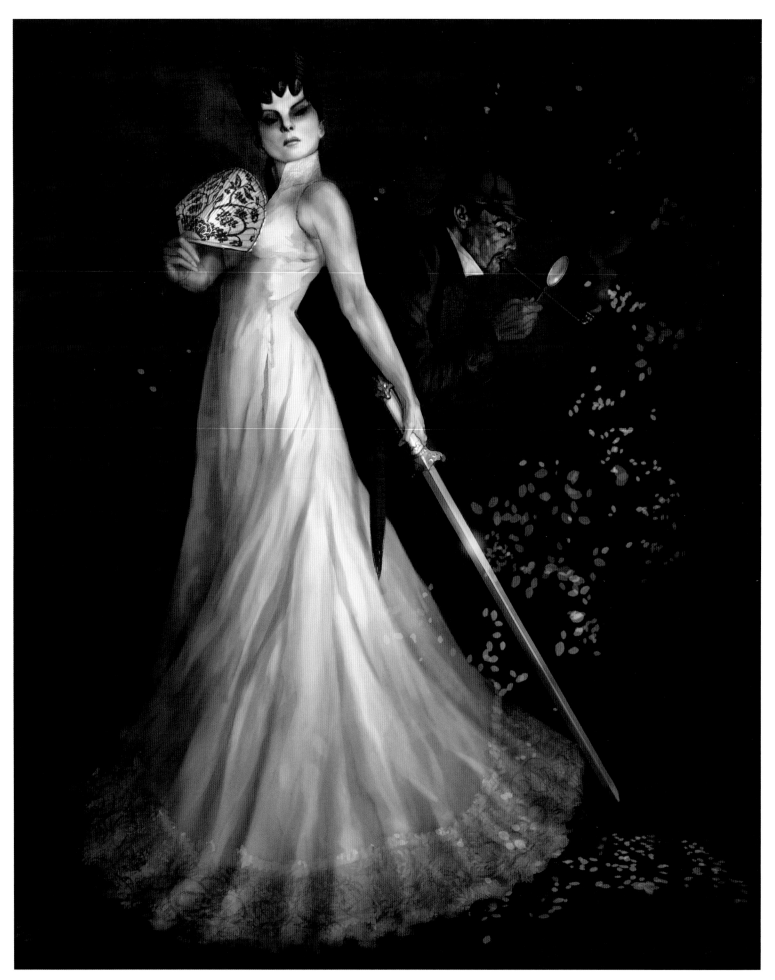

PAUL TOBIN

THE WHITE FOX AND SHERLOCK HOLMES
Coilhouse magazine, issue five, 2010

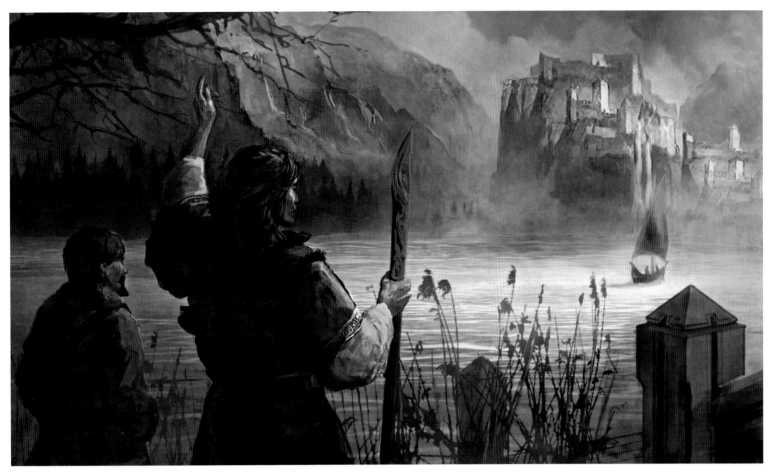

THE CROSSING
Photoshop 2009

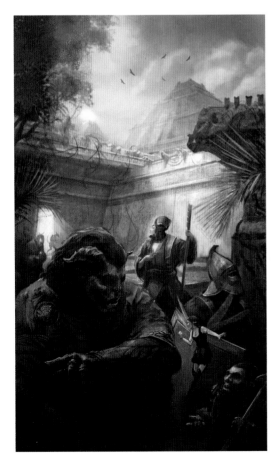

LOST IN PARLANTH
RedBrick Ltd
Photoshop 2006

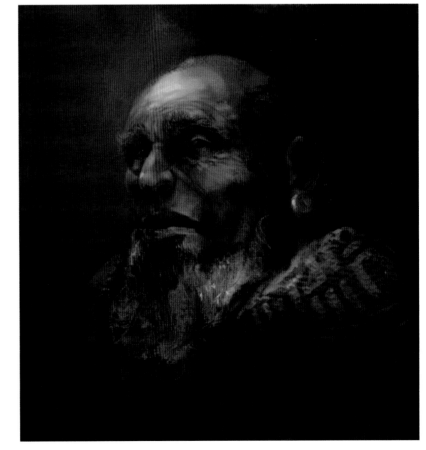

LORD OF THROAL
Photoshop 2006

PAUL TOBIN

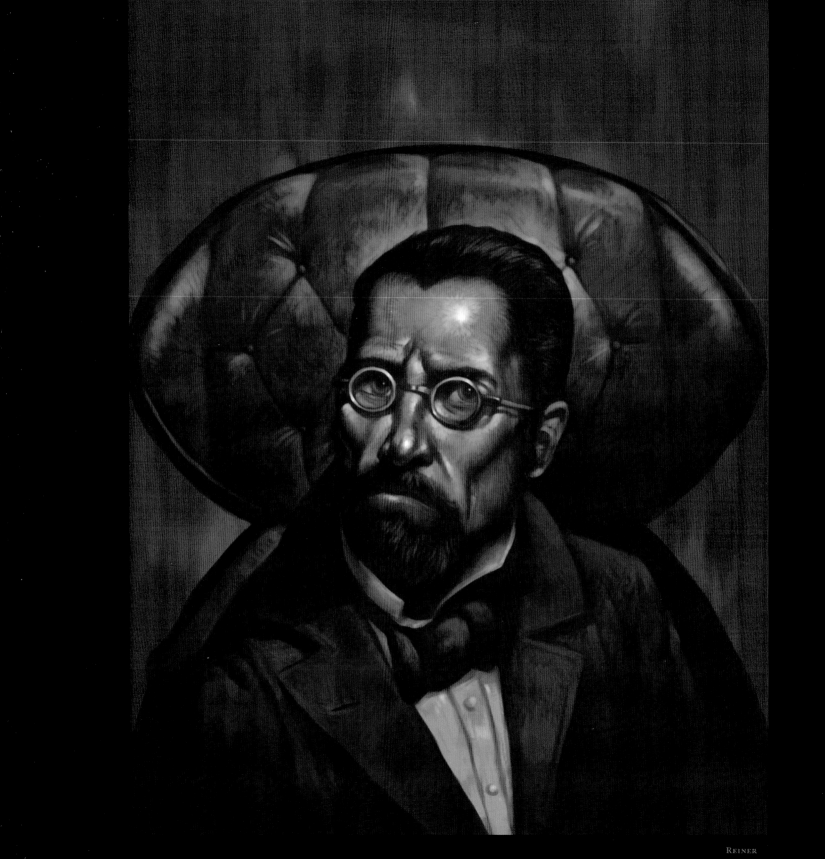

'Why don't you draw something nice for a change?'

If I had heeded those words from my parents, life might have been quite different. I'm sure that even after all these years, my parents are still scratching their heads as to how a D-grade speller with equally bad levels in maths and English managed to have a successful and well-paid life by scribbling monsters all day.

My own first memories of 'science fiction/fantasy art' and wanting to draw come from early in my childhood. I remember a large, very well-read children's book with a pastel palette, about a group of furry animals that lived in a tree trunk, and also a children's puppet TV show, once again about animals living together (a bit of a theme here). Both were set in twilight worlds where everything was in shadow except for the odd warm light from a fireplace or lamp highlighting a scene. Both were beautifully finished and created the feeling that out beyond the frame of the painting or set, the world of that story continued on.

Every six-year-old child has memories of going to bed at night, entering a dark room, running and leaping for fear of the sweeping tentacle or the hairy clawed hand that might come darting out from under the bed. I'm pretty sure I have drawn a few of those critters in the last few years! Bill Watterson portrayed this often with his character, Calvin, in his wonderful series of comic strips, 'Calvin and Hobbes'. I love Calvin and see him in my kids all the time, although they have yet to push the car into a ditch!

Once I had reached school, my mother was buying me a cheap drawing pad each week. By the following week the pages were resplendent with World War Two fighter planes, tanks, robots and monsters. A carbon copy of a million other six-year-old boys' inner imaginings, I'm sure. The 'retro-spectoscope' says maybe I should have kept a few of those drawing pads, but I was probably over my work just as fast then as I am now! It is a strange life to love your creations one moment and then despise them a week later, although it is comforting to hear that I am not alone in having this attitude.

At ten, I was reading *2000 AD*, *Sgt Rock* comics and the pocket war books, *Commando*. Once I'd hit my early teens, I was onto the pulp magazines *EPIC* and *Heavy Metal*. My drawing had developed a little by then and I had graduated from tanks and robots to dwarven fighters and orc warriors for our DandD gaming. Funnily enough, I'm still doing that now!

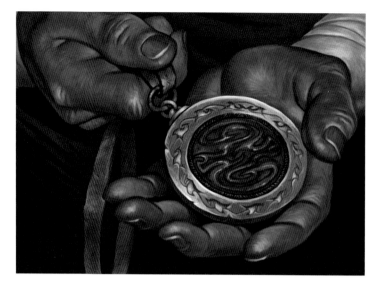

BLESSED MEDALLION OF KARABOR
© 2009 Blizzard Entertainment Inc.
Painter 2006

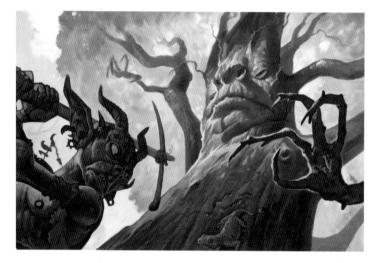

SENTRY OAK
© Wizards of the Coast LLC, image used with permission
Painter 2005

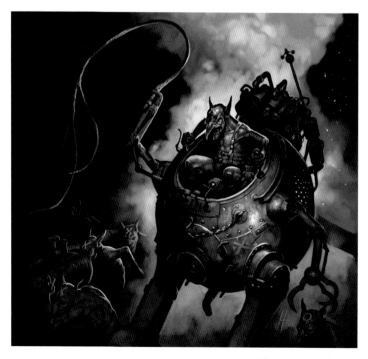

STEAMFLOGGER BOSS
© Wizards of the Coast LLC, image used with permission
Painter 2005

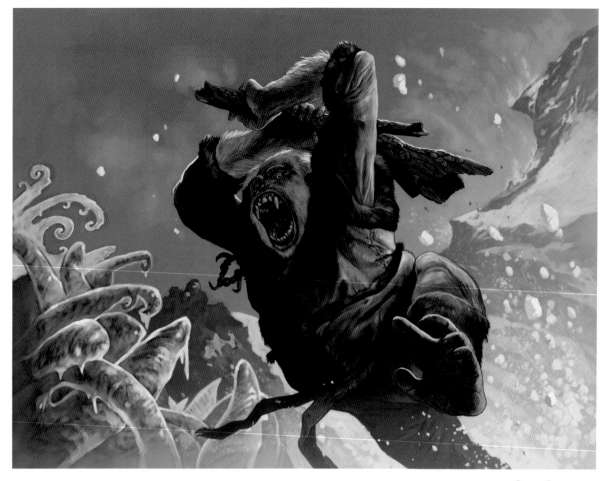

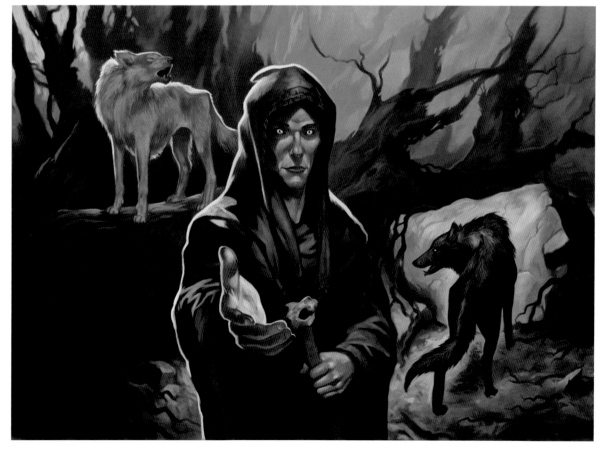

The job of a fantasy artist (or any artist, for that matter) poses serious challenges. We are always in need of a clear head space and have the constant quest for that illusive 'blue note'. The latest findings in brain science show a convergence at certain points between creativity and brain instability. I guess the trick is staying just close enough to the edge to be active at creating something that is beyond reality, but not so close that you fall into the abyss.

Having great mates who were creative and participated in an alternative reality on the weekends, combined with having the forests and coastlines of New Zealand at my doorstep, was definitely a bonus for inspiration. Cheers, Mr Wootten! I've been fortunate enough to have had the chance to stretch my creative 'legs' on some fantastic projects, whilst working alongside other extremely talented artists, and even giants of the fantasy world who inspired me when I was young. And, having grown up being told that my art could only ever be a hobby and not a viable career, I pinch myself daily at the thought that I am able to do what I do.

'Why don't you draw something nice?'

I say — 'No thanks!'

www.mahystudio.com

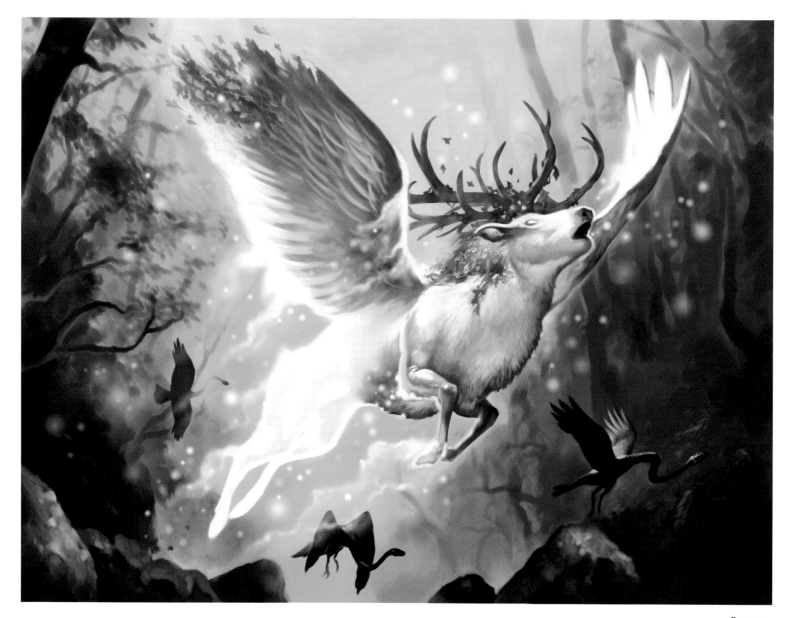

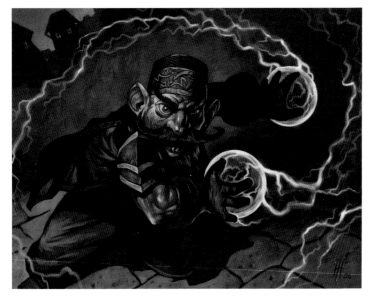

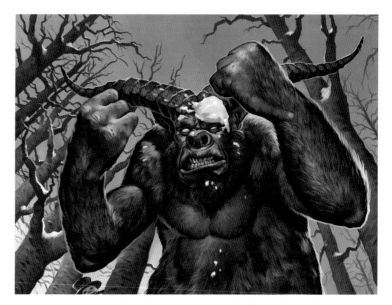

ZANDER SHADESPROCKET
© 2009 Blizzard Entertainment Inc.
Painter 2004

THE ABOMINABLE GREENCH
© 2009 Blizzard Entertainment Inc.
Painter 2006

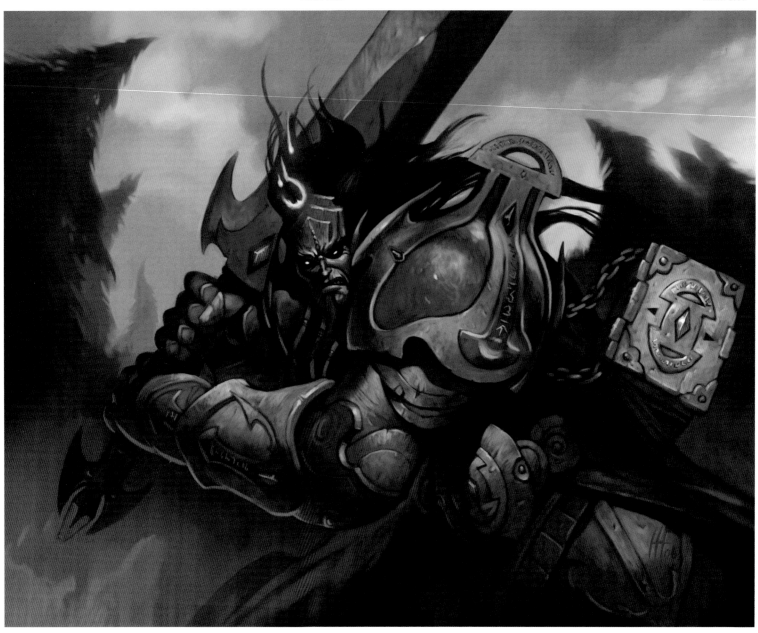

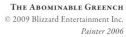

KAL'AI THE UPLIFTING
© 2009 Blizzard Entertainment Inc.
Painter 2004

WARREN MAHY

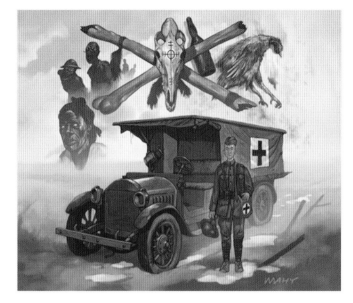

JOHNSONS RESERVE
© 2009 Blizzard Entertainment Inc.
Painter 2004

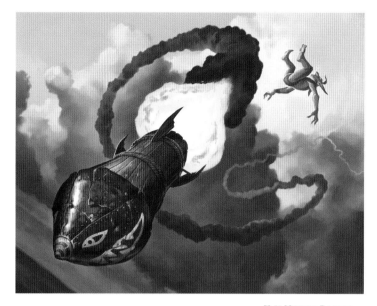

X-51 NETHER ROCKET
© 2009 Blizzard Entertainment Inc.
Painter 2006

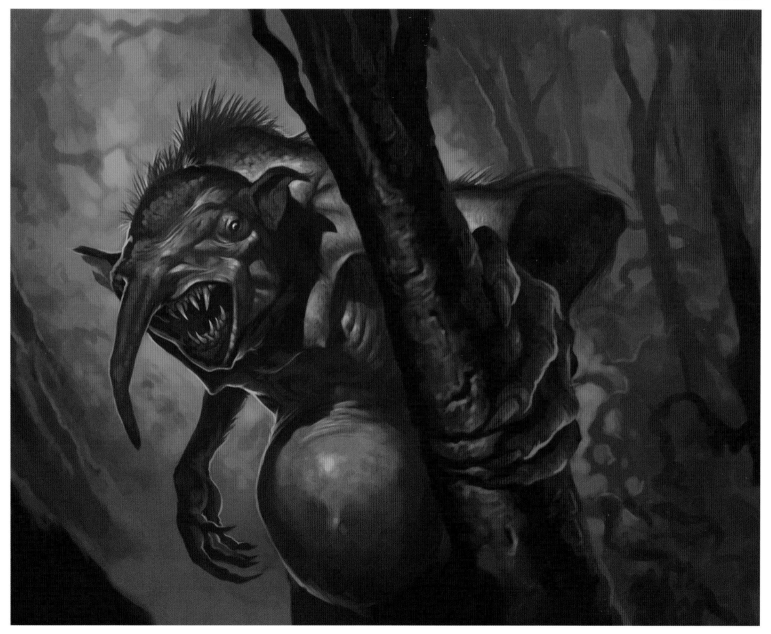

RENDCLAW TROW
© Wizards of the Coast LLC, image used with permission

REBEKAH HOLGUIN

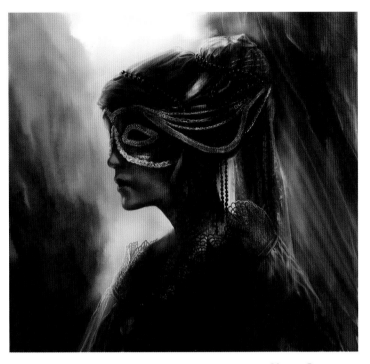

MASKED PORTRAIT
Photoshop 2009

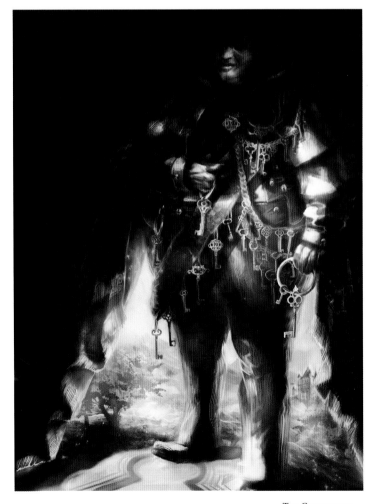

THE GATEKEEPER
Photoshop 2009

JOINING ROOTS
Photoshop 2009

I first knew I wanted to draw pictures for the rest of my life when I was around six, though admittedly this included several years of wanting to draw princesses at Disney, and several more of wanting to draw anything at Disney. However, I don't think my six-year-old self would be very unhappy at the way things have worked out so far.

I like to think I'm still somewhere at the beginning of my career, and have a lot to learn. Starting at Weta Workshop when I was eighteen was the best training I could have received in the industry, and enabled me to experiment and develop skills in many areas of illustration and conceptual art. But more than that, I was able to be part of a group of creatives who never failed to inspire and include me, and from whom I learned how to be a working artist, albeit a quirky one.

If the people in my life didn't stop me, I'd put almost anything on hold for a painting I'm in the middle of. It is an all-consuming focus that is hard to break; from getting the idea, to trying to make it come out of my head in all its imagined glory. I still haven't got the latter bit right, but I'm working on it. I am disappointed if I don't make some kind of improvement with each new drawing, and I'm driven to keep going until I have.

Even though I use mostly digital methods, programs capable of dozens of interesting techniques, I like to keep it simple, and use minimal amounts of layers and tools. Or, I might just be lazy.

I do enjoy building layers of opaque colours though, as well as adding richness with various texture and pattern stamps. I've always been interested in costume and character, and how ordinary things can be spectacular when the lighting is right. Then again, I don't like thinking about ordinary things too much if I can help it — and maybe my paintings reflect the fact that I live in an impractical, cloudy, fairy-tale world most of the time.

www.rebekahholguin.com

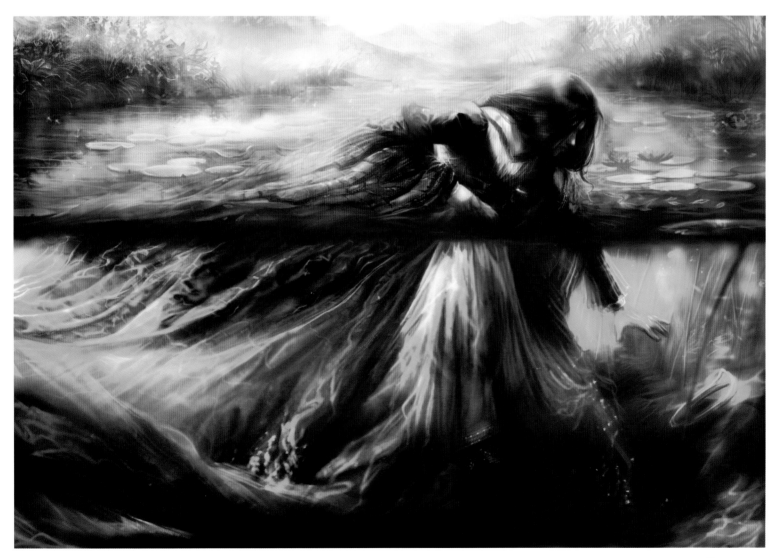

SEARCHING
Photoshop 2009

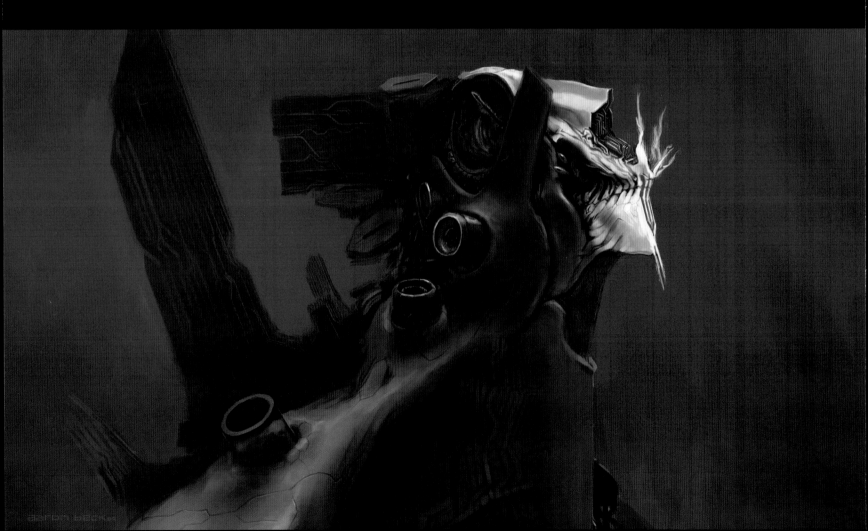

These beings are what I seem to create when I put pencil to paper with no preconceived idea of what I'm about to draw. I have been sketching them for years, and they develop as I learn more about natural history, animal life, science, technology and martial arts. In a sense, I guess they combine these favourite subjects of mine into something that I can happily scribble pictures of all day. I have always loved science fiction that pushes current scientific theories into future postulation, and I try to do this with these characters.

The overall concept is to push the ideas and techniques of traditional Eastern martial arts into the distant future, where self-evolving, nano-engineered mecha spend thousands of years perfecting their bodies and their art.

The ancient Chinese concept of *chi*, or energy flow, becomes physical in these warriors, with muscle cells stored in a 'dantien' belly tank, ready to be pumped in or out of the required muscles to balance the strength and speed needed for a specific movement. Bones shrink or lengthen and joints expand or contract along with muscle anchor points, to increase the effectiveness of a strike. All the cells which make up the body have their own degree of atomic-scale, quantum-computing-based intelligence, making the entire body one sentient entity. The outer skin surface is covered in sensory cells sampling their entire surroundings. Key physical elements are inspired by those found in nature; for example, eyes based on those of a mantis shrimp, which possesses the most advanced visual sense of any animal on earth, and pads on the digits, like those found on a gecko, equipped with branched setae hairs to generate intermolecular grip.

The whole is more than the sum of its parts.

I like to envision one of these characters portrayed in an animation as seemingly stationary on a mountainous cliff face in some distant-future evolved earth. The body squats in a *kung fu* pose, the surface grey with built-up dirt and lichen, animals and plants living in the cracks in its form, a small tree growing twisted around a leg. As the camera pushes in, time starts to speed up, and the clouds begin to race overhead. The movements of the animals and other lifeforms that live around and in the statuesque figure flicker faster and faster. Days passing in seconds

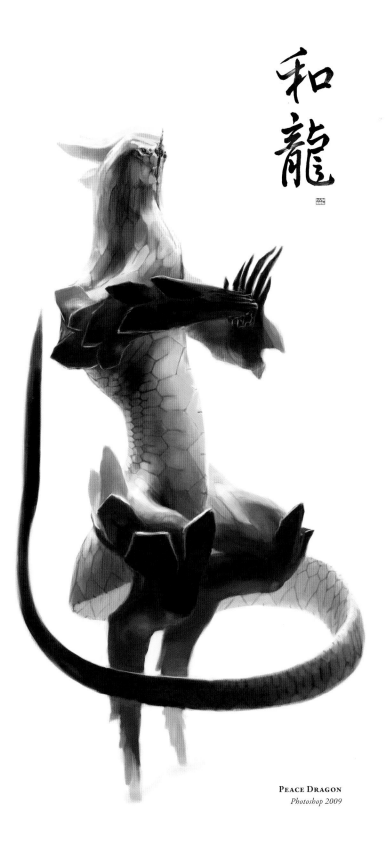

PEACE DRAGON
Photoshop 2009

turn to months, faster, faster, until seasons are visible as flashing colour shifts. Still we increase the passage of time, the tree around the leg is seen growing and dying, erosion is visible in the surrounding rock, and we begin to see that the

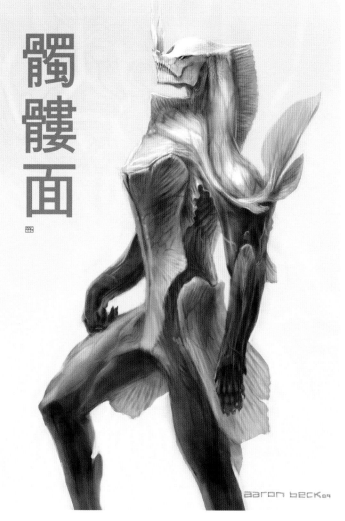

髑髏面

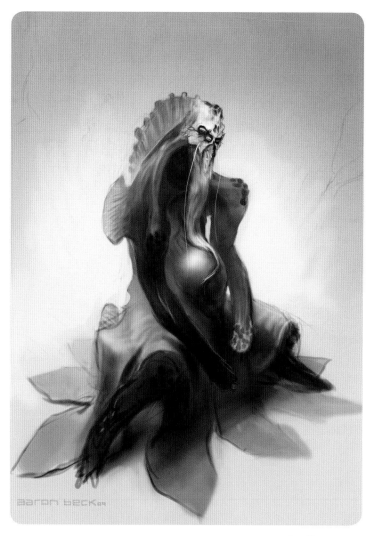

UNTITLED
Photoshop 2009

OLD KNUCKLES
Photoshop 2009

statue is in fact moving, at a pace only visible on this geological timescale. The being is moving through a graceful pattern of *tai chi* forms that takes 10,000 years to complete. A dedication to its art verging on the incomprehensible. Upon the completion of the sequence, the being's eyes flick open, intelligence clear in the gaze. A rising hum sounds, culminating in a sharp ultrasonic vibration of the body that clears away all the built-up debris, revealing a colourful and intricately detailed form. The mecha then launches into a brutal high-energy *kata* of monumental power. Rock walls are shattered and melted as the mecha strikes with fists that ultrasonically vibrate, propagating cavitation waves in the stone. Sonic booms from striking limbs echo across the valley. The mecha finishes, petal-like heat sinks, expands and glows pink as excess heat is dissipated from the body, white-hot fists and feet shimmer and distort in the heat haze.

www.skul4aface.blogspot.com, aaron@apbworks.co.nz

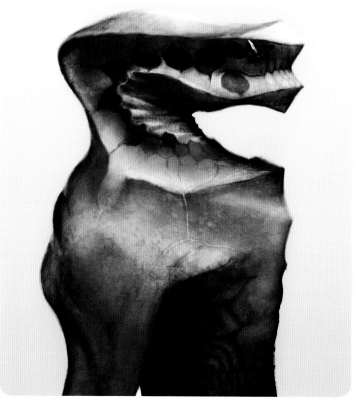

SNAKE FOR A FACE
Photoshop 2009

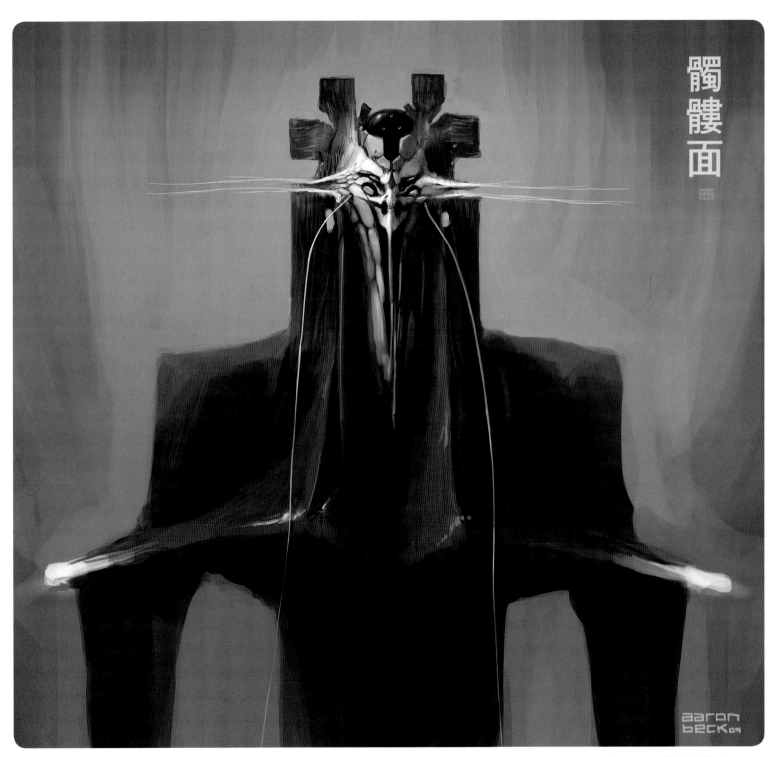

髑髏面

UNTITLED
Photoshop 2009

(following) **SKUL4AFACE**
Photoshop 2009

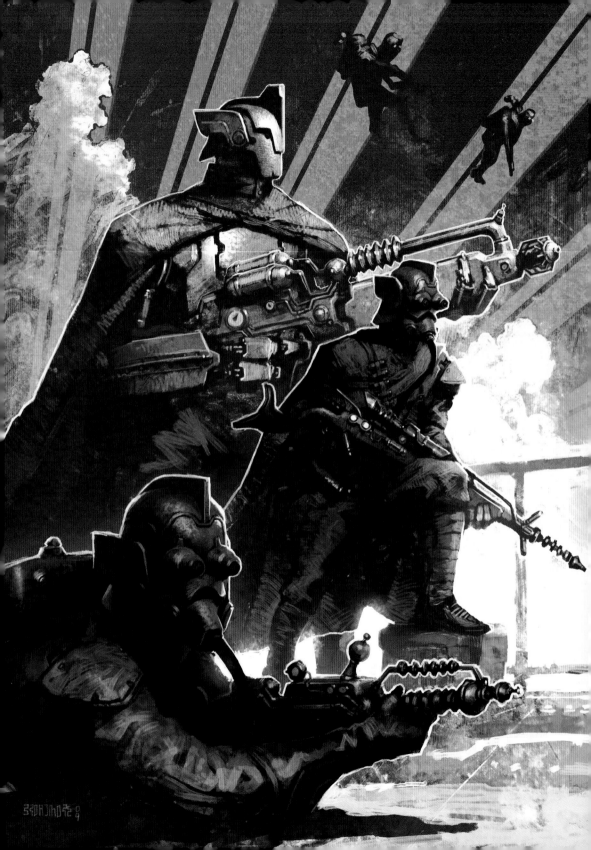

Greg Broadmore — artist, writer, professional naked downhill mountain biker, cock fighter, competitive hair stylist, breeder of guinea pigs and so much more. What didn't he do? It's hard to say really, as he was such a whirlwind force of nature — always pushing the boundaries of life and love. An Adonis of a man and an athlete of immeasurable skill, his presence in any room was felt and witnessed with awe and respect.

His chiselled abs could tent-pole the trousers of the hardest homophobe and a cursory glance from his sultry green eyes, welling deeply with unfathomable emotion, could melt the vagina of the most glacial ice queen.

He took on life as a starving great white shark takes on a fat scuba-diver covered in delicious fish paste, and he left few morsels.

And then there was his art.

Broadmore painted only in the wee hours — between 4 a.m. and 5 a.m. every second Sunday — owing to his profound superstitions. He attributed his prowess and success in life to his survival of a terrible yachting accident at sea in his youth. He clung for thirteen harrowing days in the Gulf of Mexico to his first beloved painting (its heavy-handed impasto finish provided seemingly impossible buoyancy) and vowed after he was rescued by Indonesian pirates to paint only during those auspicious hours of his salvation.

Why every second Sunday? Nobody really knows, but the only person ever to have asked (children's TV presenter Ollie Olsen) was punched clean out of the room and woke after a three-week coma with no recollection of the event.

The painting that saved his life depicts a skyscraper-sized astronaut being surprise dry-humped by Winston Churchill on the moon and it hangs to this day in the Te Teko town hall, above his mayoral portrait.

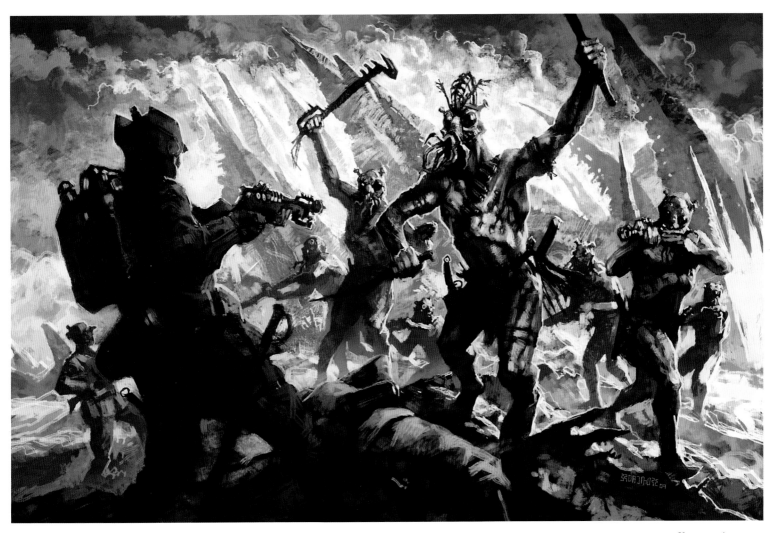

VENUSIAN ATTACK
Dr. Grordbort's
Tania Rodger and Richard Taylor
Photoshop 2009

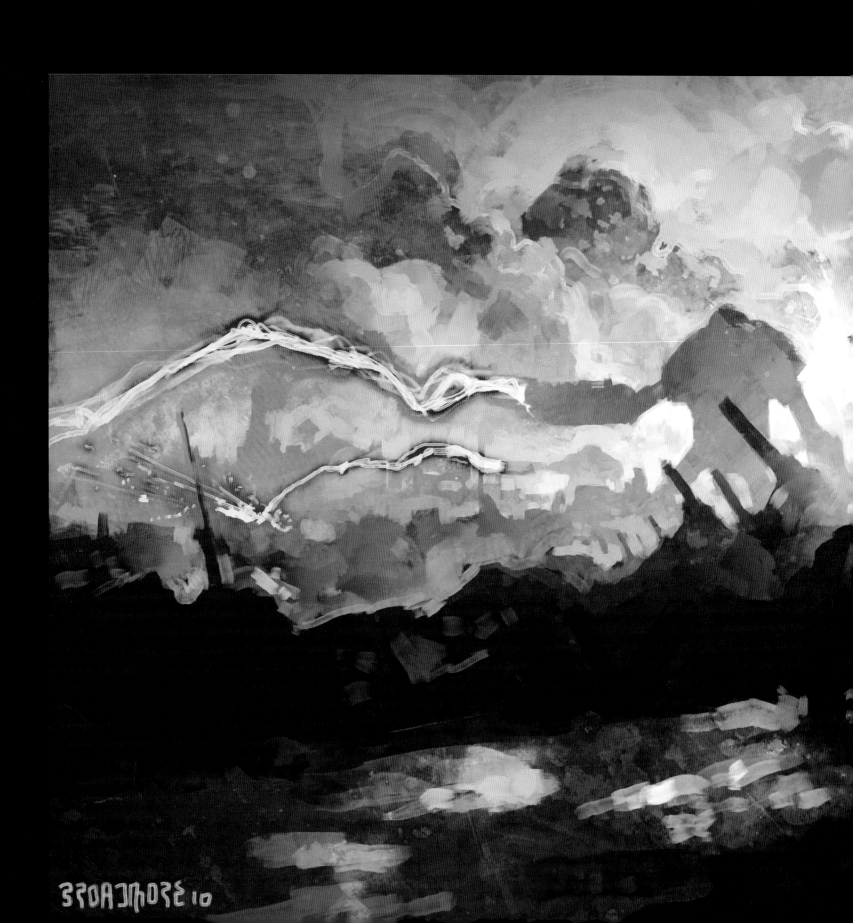

BROADMORE 10

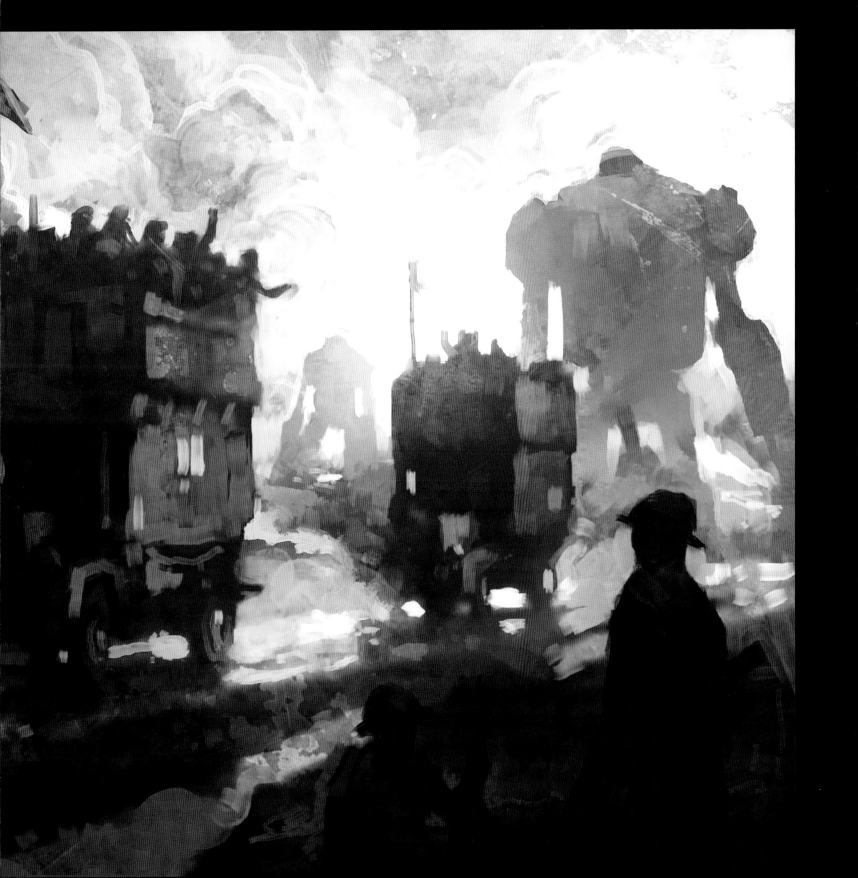

Many visit the image in a yearly pilgrimage and, in the past, after licking the canvas, claimed that they could still taste the Gulf's distinct salty residue. Licking 'The Old Puncharoo' (as it is titled) is now strictly prohibited because of the cumulative abrasive effects of such intensive tongue action. These adoring lickers unwittingly damaged the priceless piece beyond repair, but their actions did, however, lead to the discovery of an under-painting — the original astronaut seems to have once been a giant, overweight David Hasselhoff.

Despite what we see on these pages, Broadmore's favourite illustrative subject matter consisted of pastoral scenes of sixteenth-century France. Evocative yet drily historical depictions all, if it weren't for the naked go-go dancers piled high like haystacks in the centre of each image.

Each new piece floored the art world, mesmerizing all with their gestural elegance and glorious god rays. So powerful were the

images, the best were sold as cover art for blank vinyl records and these records would enter the US and UK pop charts usurping popular musical acts of the time like Boston and Dexy's Midnight Runners.

To this day, aficionados still listen to those blank recordings with reverent fondness claiming to hear the essence of the art whispering through the crackly white noise like the ghosts of imprinted genius.

Few of those masterworks survive, however, and only these eight of his most inept renderings are available for reproduction — all commissioned by *Sexy Space War* magazine during the late 1970s.

Greg was said to have despised this type of science fiction and fantasy art, calling it 'vapid entertainment for the simple and unfortunate'. He would paint such works in a fury, bellowing insults and profanities, often holding down a canvas and beating

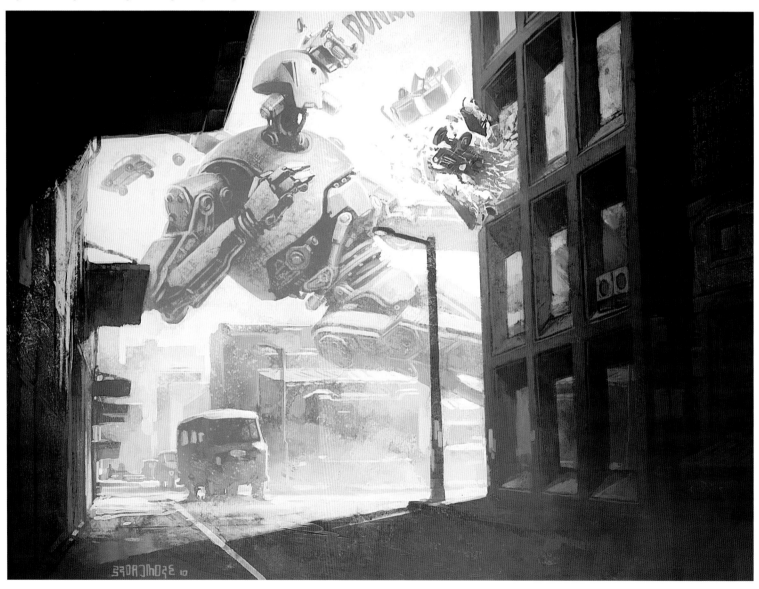

it mercilessly until his knuckles bled. This was perhaps the only way he could withstand the insult to his talent that he believed these images represented.

And yet he made these images, these affronts to his discerning aesthetic sensibilities, these populist garbage piles of fantasist piffle, these mile-high shit-piles of shitty-shitty bum poohs.

Why, we might ask, did he put himself through it? Perhaps it was that he needed the money for his mother's multiple hip operations (he was prone to kicking her in the hip for its comedic yet expensive result, especially straight after an operation), or his opulent but never-completed mansion in the backlots of Taneatua, or maybe it was his addiction to all known drugs. Actually it was probably all of those things — he was an absolute dick with his money.

Needless to say, he was taken from us too soon, stolen in his prime. Cursed from his youth with both muscular and genital gigantism that worsened throughout his years, he simply suffocated one day within the folds of his own massive pectoral muscles.

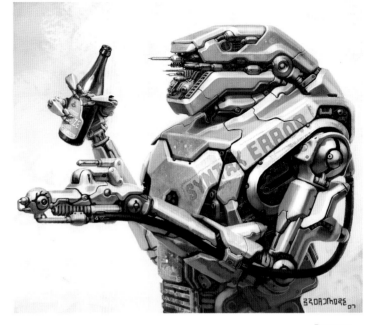

BEERBOT
Photoshop 2007

A tragic yet powerfully masculine end to a tragic yet powerfully masculine life. His art will live on.

www.thebattery.co.nz, gregbroadmore.blogspot.com

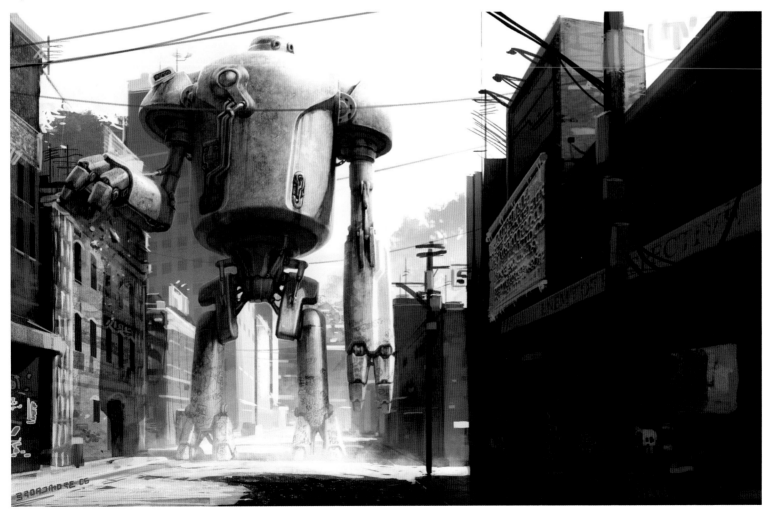

LONELYBOT
Photoshop 2006

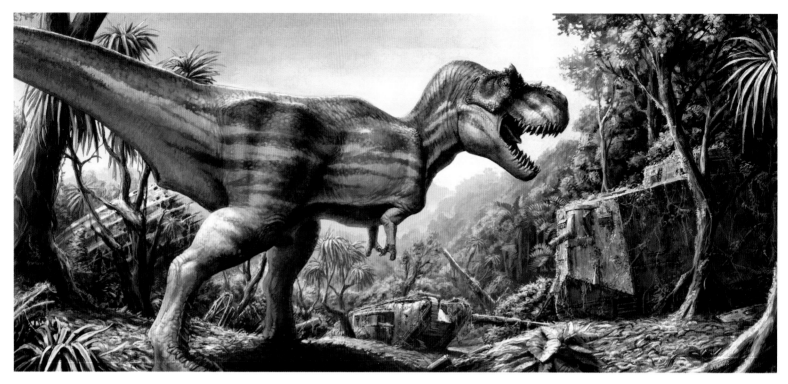

WETA MURAL
Tania Rodger and Richard Taylor
Photoshop and Painter Classic 2003

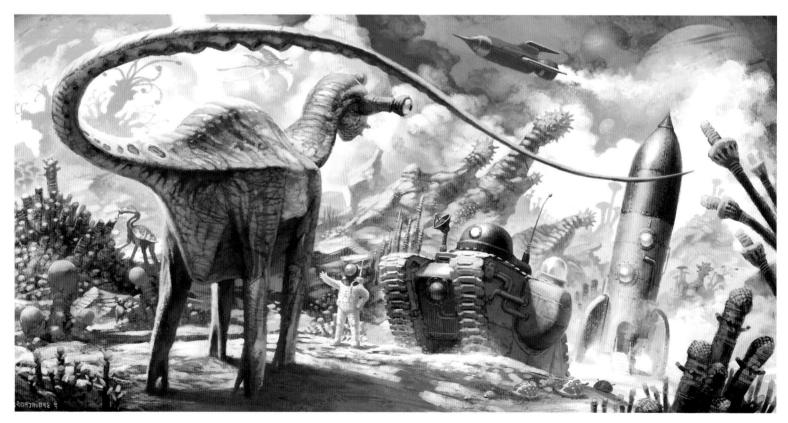

IDRISPOD MEETS EARTHMAN
Photoshop 2007

GREG BROADMORE

CHRISTIAN PEARCE

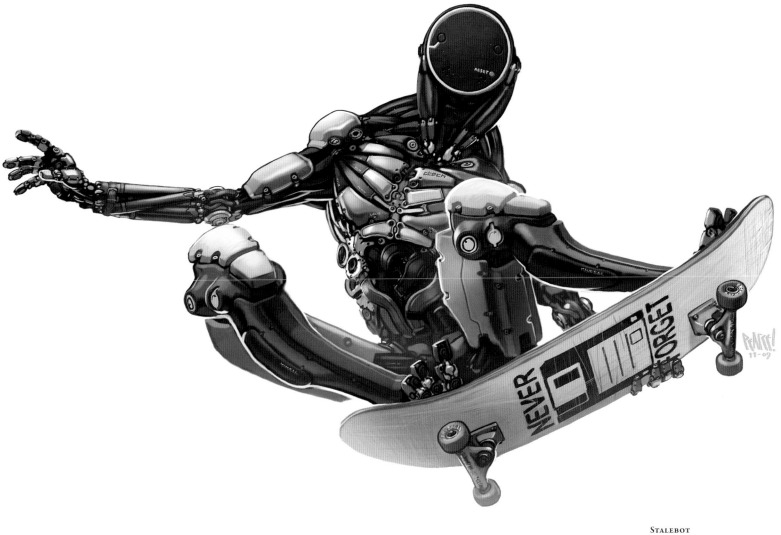

STALEBOT
Pencil and digital 2009

I like robots. I like to draw robots — I certainly like drawing robots more than drawing people. And no, it's not because I'm some sort of socially backward, twisted, misanthropic weirdo — that's a mere coincidence. I like drawing robots because you can get away with so much.

'That's a weird-looking picture, dude. Why are his legs so long?'

'Uh, that's a design feature. The Mk VII Murdernator had a severe crotch-dragging problem and this Mk VIII model addresses that.'

'Well, what's up with that goofy-looking arm? Why is it in that awkward position?'

'That's actually one of the *main* design features.'

'How come he —'

'Design feature.'

You draw a person wrong, everybody knows it. We're pretty familiar with humans as a race and have grown quite adept at spotting the ones that are grotesquely mutated or have faulty perspective. Even people who don't consider themselves artists can spot a CGI character in a film or can tell that even the most finely sculpted wax portrait isn't a real, living person. We look at people every day.

But how often do you encounter titanium-framed, gyro-stabilized, lithium-ion-powered, basketball-playing androids? Once a week at most. At *most*. You have a lot of leeway in screwing up a drawing of one of those guys.

That red guy way over there on the far right started as a quick pencil doodle. Initially I had sketched in a whole bunch of cops, surrounding him, but very early into the painting I realized I didn't want to paint a whole bunch of cops, so I ixnayed 'em. About halfway through the colouring-in, it dawned on me that I draw way too many blue robots. For me, working digitally has many advantages over painting traditionally — the eyedropper is pretty useful for us colour-blind types, as is 'undo' for us . . . uh . . . proportion-blind ones. Of course, all these positives are secondary to the main purpose of computer-based painting apps — turning a blue thing into a red thing.

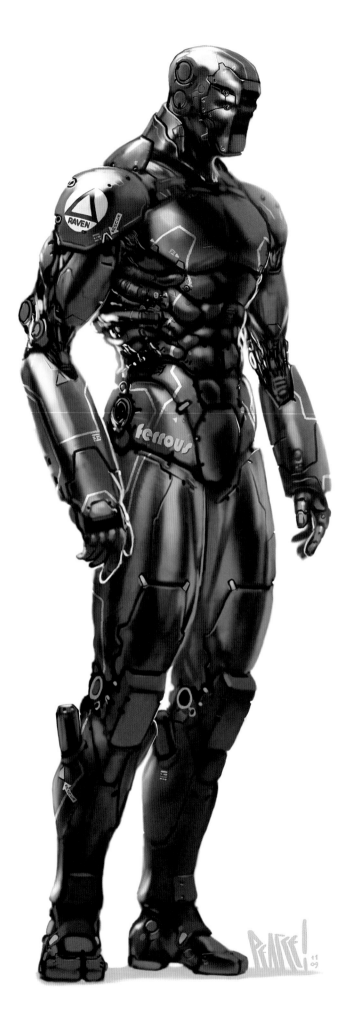

OL' BLUE THIGHS
Pencil and digital 2009

CHRISTIAN PEARCE

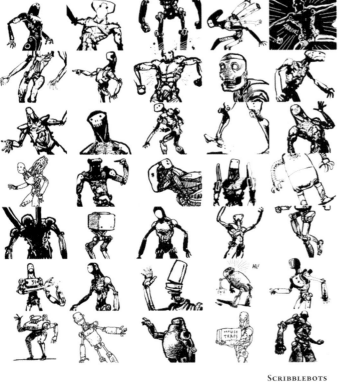

SCRIBBLEBOTS
Nintendo DS 2009

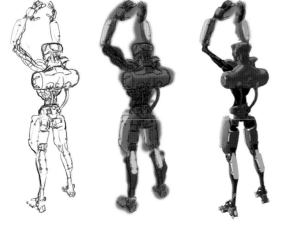

FREETHROBOT PROCESS
Pencil and digital 2008

What the heck is he supposed to be doing now, though, since laziness severely reduced this piece's police presence? A one-man Mexican wave? Shooting a free throw? Giving it up for Bishop Brian Tamaki?! Ha ha! Only if he's got 2K of RAM, lol.

What about those black-and-white techno-blobs? Are they some sort of poorly scrawled, vaguely robotic Rorschach test? I drew 'em real quick-like on my Nintendo DS using the homebrew app Colors and they actually *are* a form of Rorschach test. They're used to clinically diagnose dumb jerks. You don't see a bunch of abnormal automatons in there, do you? Uh oh . . .

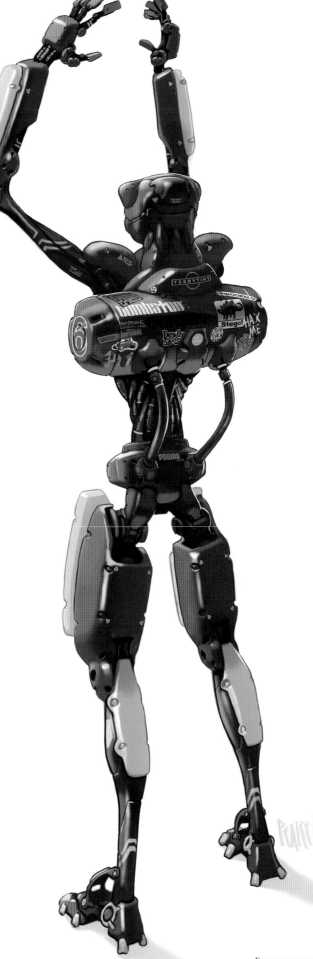

FREETHROBOT
Pencil and digital 2008

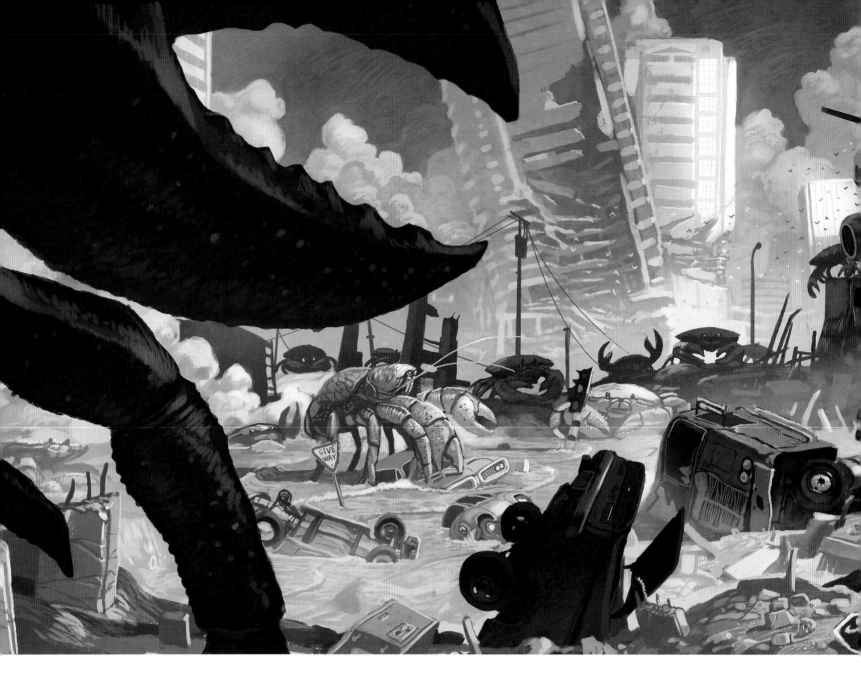

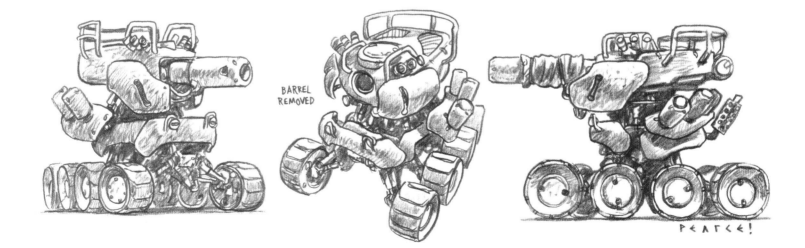

BARREL
REMOVED

PEARCE!

CHRISTIAN PEARCE

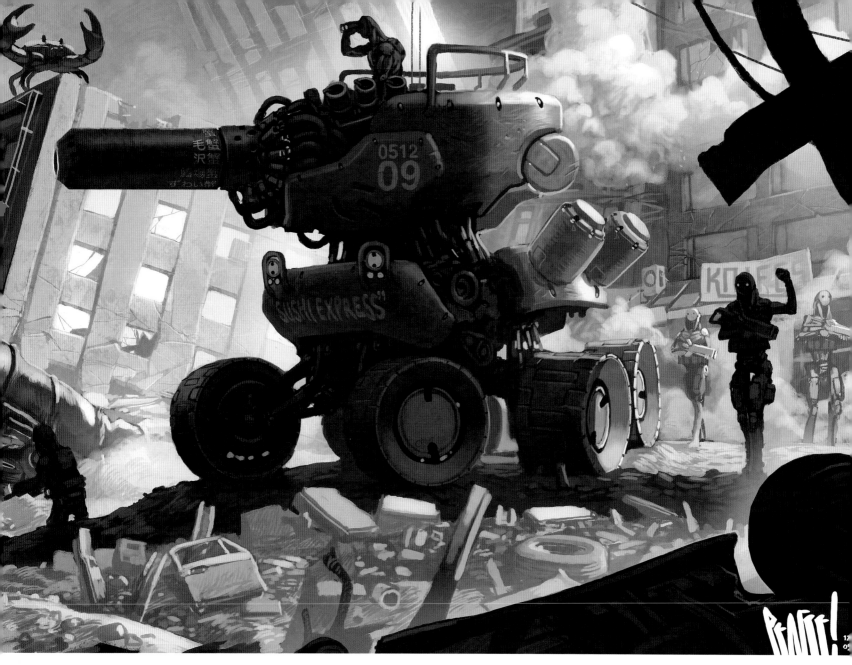

Crabs don't like robots. I tried my best to capture this ongoing feud here in illustrative form while at the same time attempting to visualize the intangible tension brought about by our ever-more technology-dependent society and our moral ambiguity about our psychological and physical separation from nature. Then I drew a futuristic space tank and robots with machine guns, also some wasted buildings.

I had these little sketches of soldier robots and a kind of *Metal Slug*-inspired tank lying around. I put them together for this piece mainly 'cos repainting old ideas is easier than coming up with new ones. I really tried to work differently from how I usually do with this one and kinda hoped that a limited palette would speed things up. Oh no, it didn't! What a nightmare!

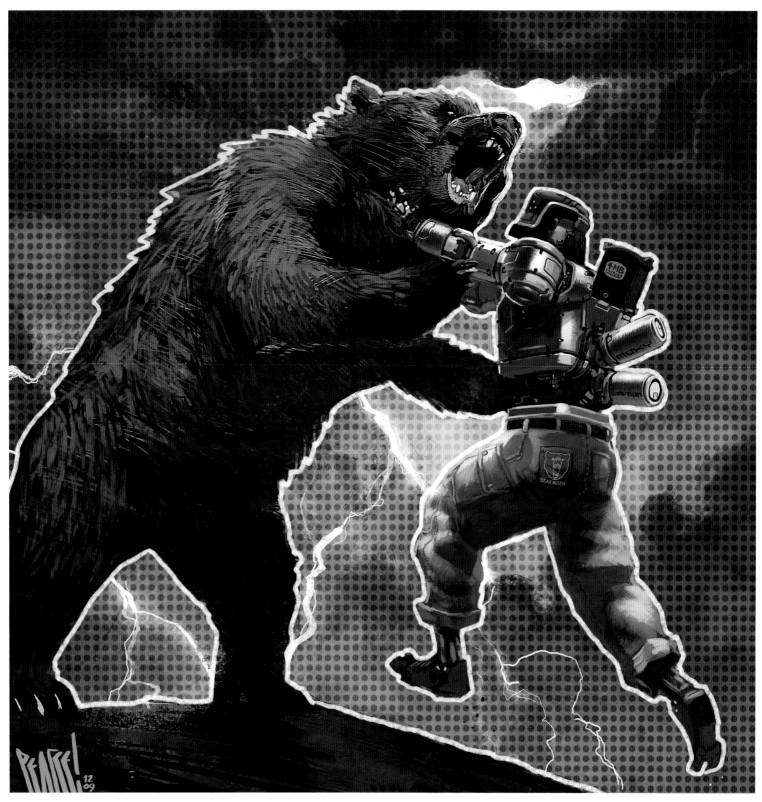

THAT AGE-OLD FIGHT OF BYTES VS MYTE
Pencil and digital 2005, reduxed 2009

CHRISTIAN PEARCE

I tend to draw my robots pretty humanlike, proportion-wise. I guess the idea that they can use all our stuff once they get rid of us is pretty appealing. Ride our bikes, wrestle our grizzly bears, wear our dresses . . . not that I'd ever wear a dress! What a ridiculous concept, the very idea is laughable! I don't know what you think you saw that night but it certainly wasn't me in an evening gown. It's absurd. You're crazy!

Those ye-olde-looking fellas over there *are* actually pretty olde, like 2005-type vintage. They were for a highly successful, critically acclaimed alternative vision of World War One calendar and poster series. By 'highly successful' I mean the calendars had the dates printed legibly on them. And what does 'critically acclaimed' mean? That's just another way of saying 'I have piles of unsold calendars rotting in the basement', right? Sure, it's a fairly abstract way of putting it but hardly misleading. I guess the calendar-buying public wasn't ready for vintage robots illustrated with so many glaring . . . um . . . design features.

www.christianpearce.net, christian.b.pearce@gmail.com

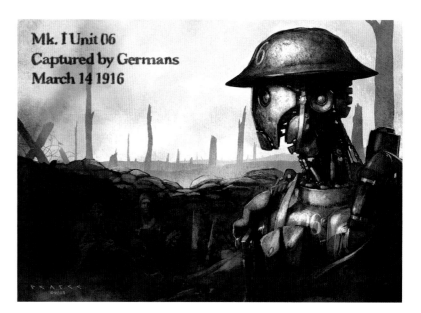

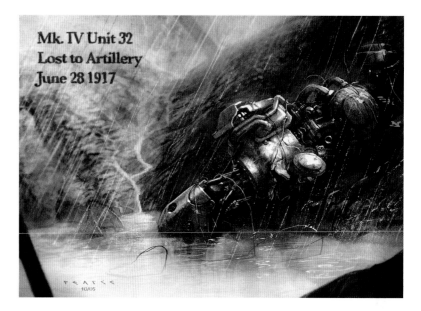

BearBusterBot
Pencil 2010

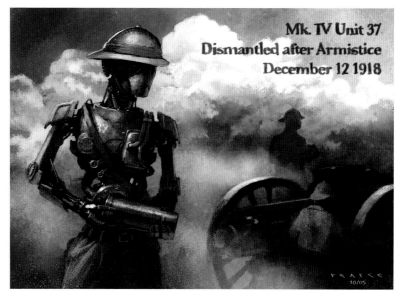

Techno Tommy Triptych
Pencil and digital 2005

ANDREW SHAW

As a freelance illustrator, my day-to-day work tends to be structured and client-directed. Quite often there are images or worlds that grow in my subconscious, and I believe it's important to get these out. A lot of my personal art tends to be free-flow, fun pieces that don't take themselves too seriously.

The works on this page were all exhibited in a group exhibition called 'Attack of the Art Beast'.

My process is the same as I'd use to create any illustration. I begin with small pencil thumbnails. The small thumbnails help me make decisions about the composition and the balance of tone in the image. I then scan the one that's working best. In Photoshop, I experiment with colour washes. In this case one of my foremost considerations was the balance of how the beasts would sit in the environment. I wanted them to feel integrated into the scene, but also to clash or look like they're not 'from there'.

A really pleasing stage of the process is dreaming up little background narratives for the minor characters in the images. Most of the time the viewer might not initially pick these up, but it makes design decisions much easier and adds a fun secondary level to the piece. The rendering stage is really satisfying. Once most of the main compositional challenges have been solved, you can concentrate on where to put the detail, or, as is often the case, where to leave out the detail. In these pieces, one of the things I was concentrating on was the play of light and shadow, giving a sense of atmosphere, scale, and a feeling of 'epicness'.

I'm currently enjoying documentary-style drawing, capturing people as they go about their everyday tasks. Quite often this involves sitting in the local library, drawing people as they read. I like the honesty that you can see in people's poses, the varied types of folk you see there, and the challenge of capturing a 'moving target'.

One thing I'm really keen to explore further is early New Zealand stories. When I read our history, it's very much like a sci-fi story. Huge alien vessels with white sails. Maori in an instant being confronted by the awareness of a world much bigger than

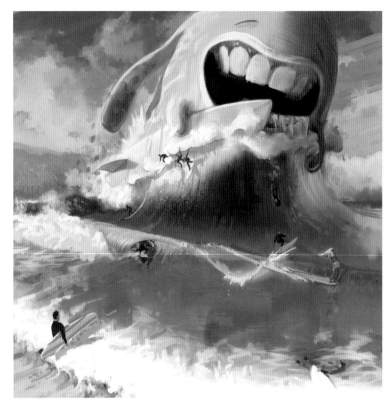

LBC
Photoshop 2008

their own. Tales of European settlers adapting to a rugged and unforgiving landscape.

I guess the reason for this interest came from travelling recently, and returning to New Zealand with fresh eyes. Arriving back in Wellington, initially I was frustrated. I missed the sense of ancient art and culture that European cities have. For instance, I was able to hang out in a café in Paris that is older than our European history in New Zealand! It was something that was playing on my mind for some time.

I've since come to realize that our comparative lack of history does have an upside, though. The beauty of living in The Land of the Long White Cloud is that we have complete freedom. We aren't necessarily tied down by traditions, ways of living, ways of being, like people in other countries. We are free to forge our own path, create our own reality.

www.andyshaw.co.nz, andy@andyshaw.co.nz

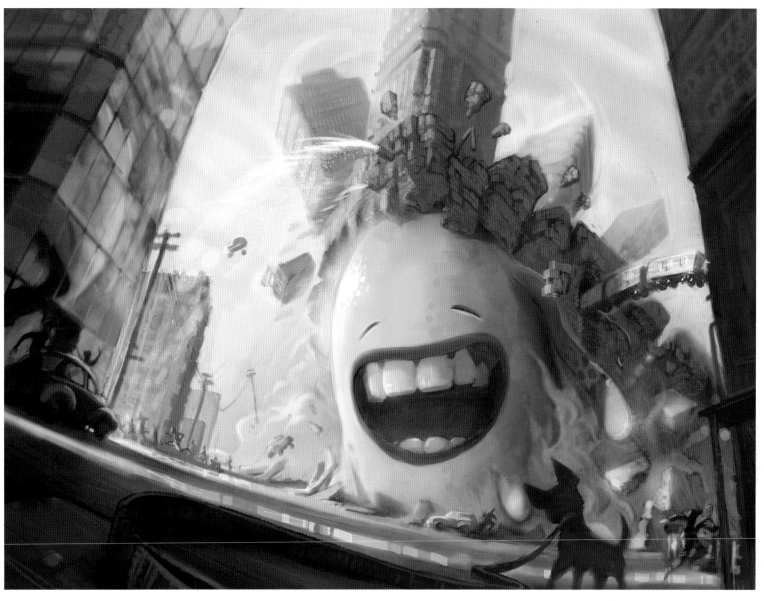

METRO
Photoshop 2008

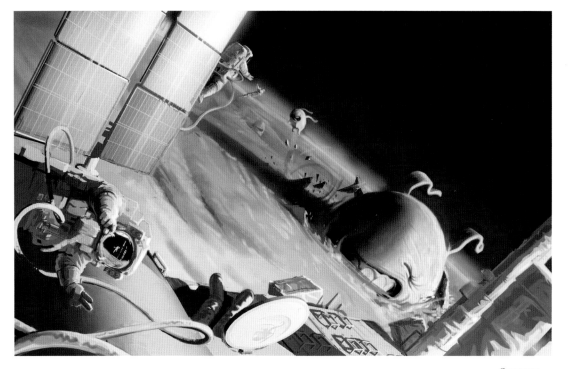

ORBITING
Photoshop 2008

ANDREW SHAW

NICHOLAS KELLER

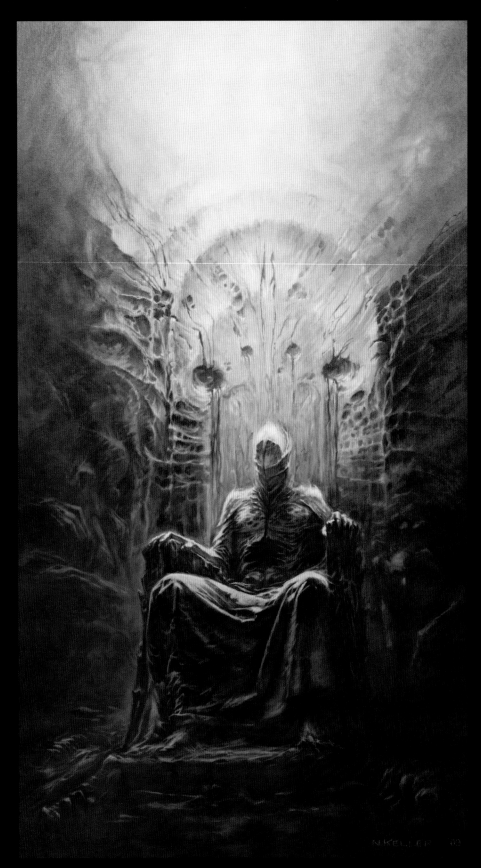

UNTITLED
Oil on canvas 2009

I've been interested in various forms of art, particularly drawing and painting, for as long as I can remember. After studying painting throughout high school, I was unsure of where I wanted to go career-wise and ended up taking on engineering at university — as opposed to continuing with art at a tertiary level.

After completing a degree in civil engineering, I decided to change my career path and pursue my passion for painting and illustration. The film industry seemed to be an exciting avenue for the creative work I was after, so, after being invited to join the design department at Weta Workshop in late 2006, I began work as a conceptual artist/designer. While this job requires the use of digital media, i.e. Photoshop, I have thought it important to continue using traditional media for much of my personal work. Currently, oils are my primary medium of choice for painting.

The pieces displayed here are a sample of personal works done over the past few years. For some reason I seem compelled to delve into the dark or disturbing realms of my subconscious when exploring my fantasy painting, and this is particularly true of my more surreal compositions. The Polish fantasy artist Zdzisław Beksiński has been significantly influential to my painting in recent years. His surreal, post-apocalyptic landscapes explore a haunting and dreamlike aspect of the human psyche which I find quite fascinating.

My most recent process in going about creating my oil paintings has actually included a digital component. From a loose pencil sketch, I then use Photoshop as a quick means of establishing composition and exploring colour palette. This is usually not a set-in-stone look but more of a rough guide as the oil painting tends to take on its own evolution from the initial digital sketch.

For me, fantasy painting is a compelling means of exploring and crystallizing the imagination in a powerful visual language.

www.nickkellerart.com, nickbkeller.blogspot.com

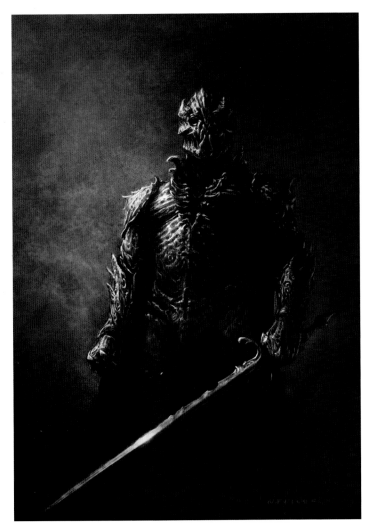

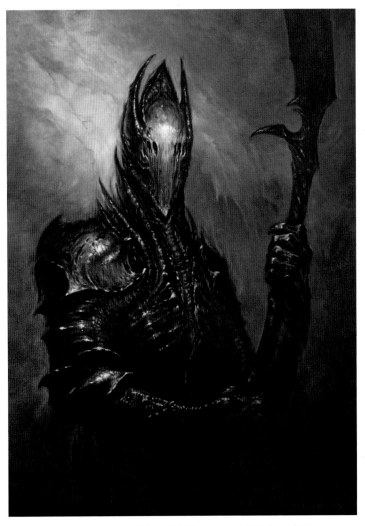

UNTITLED
Photoshop 2008

(above) **UNTITLED**
Oil on canvas 2009

(following left) **UNTITLED**
Oil on canvas 2009

(following right) **UNTITLED**
Oil on canvas 2010

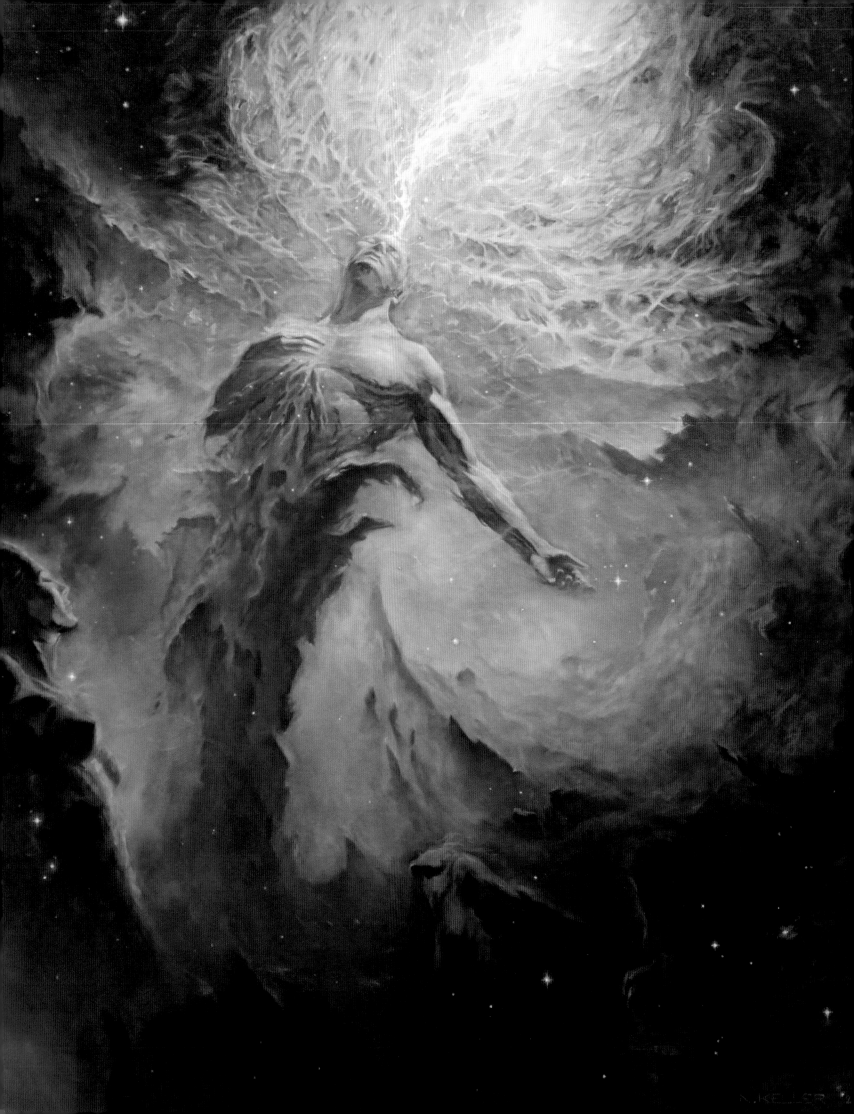

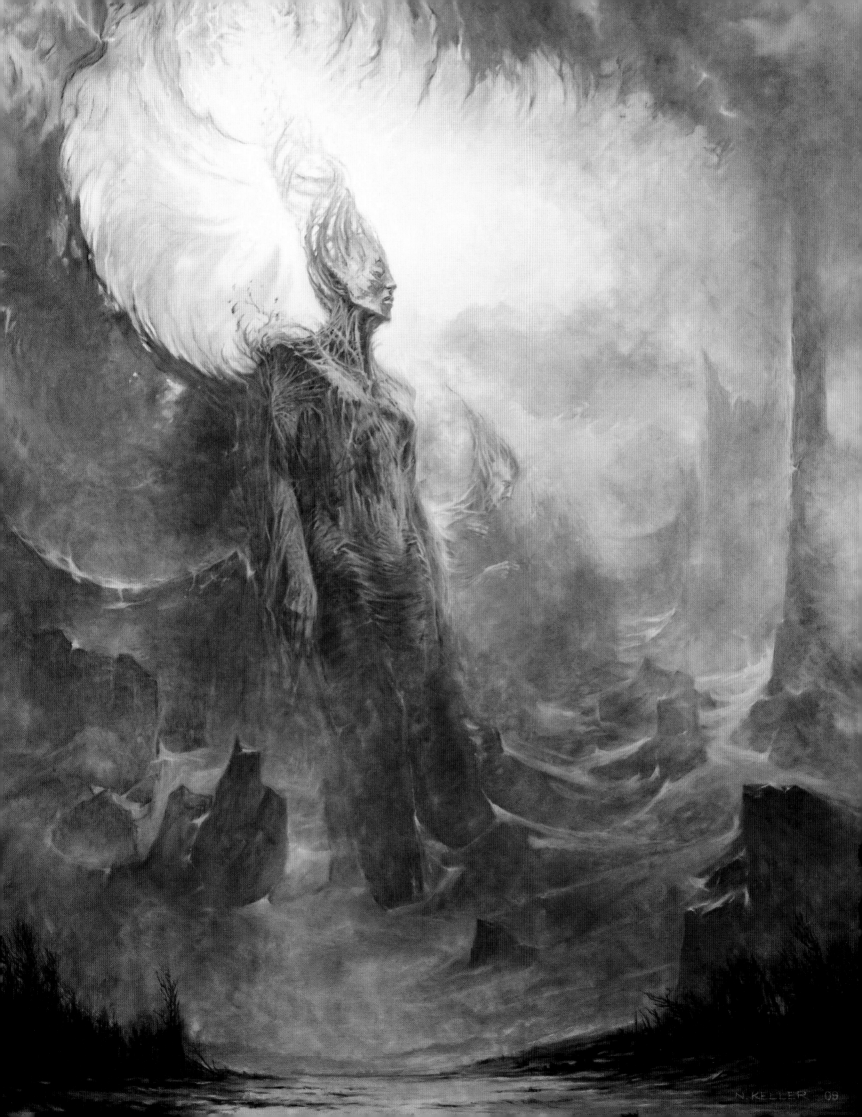

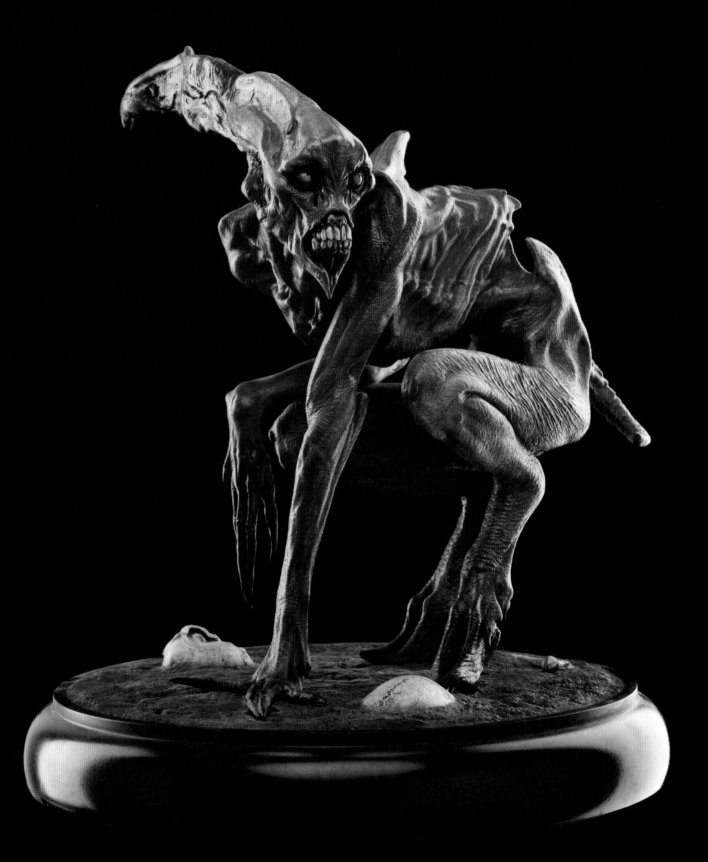

TERRAKULA
Richard Taylor/Weta Workshop
Resin moulded from Chavant 2006
Photography by Steve Unwin

Creature design has always been something that fascinates me. An appreciation for aesthetics and an aspiration for realism were rather rudely thrust upon me when I was about five and I was given a book that included instructions on how to make a papier-mâché dinosaur. My father attempted to build it for me and the result was horrifyingly underwhelming when compared with the picture in the book. I had always had a fascination with animals and the world around me, so even at that age I understood when something was wrong.

I saw *Return of the Jedi* when I was ten and was given a copy of Dougal Dixon's *Life after Man* in the same year. These designs were different. They existed believably within their own worlds. There was something so compelling and intriguing about the ideas and forms of the creatures that I was spurred to begin drawing and crudely sculpting creations of my own. I plodded along, on and off over the next few years, feverishly trying . . .

I taught myself to sculpt through trial and error, stumbling and grappling through various plateaus of understanding the anatomy, how to control the clay or Plasticine, etc.

Sometime in my mid-teens I had a literal 'Eureka' moment. While I was in the bath, it occurred to me that the desired object was already there for me and I just had to pull it out of the clay. There were many dark and wondrous days spent idly accruing a massive student loan while pushing round ideas in clay. Life-drawing taught me how to see an object in different ways in order to understand it better.

I was very lucky in that there happened to be a company in New Zealand employing people with my skills and interests, and my timing was great because they were looking for new designers and sculptors. I started at Weta in 1996 and have been with the company ever since, designing creatures for a number of projects over the years. So now I work for a company named after a giant, spooky, local arthropod and my job is basically to realize children's nightmares armed with mud and sticks — but I have yet to create a papier-mâché dinosaur that I am truly happy with.

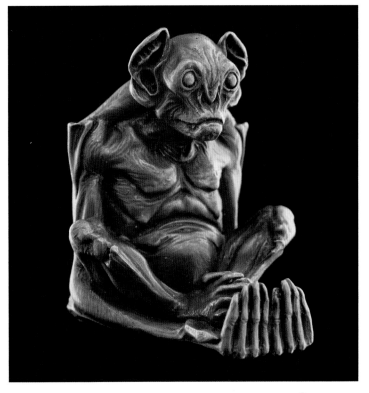

GROTESQUE
Bronze moulded from Chavant 2008

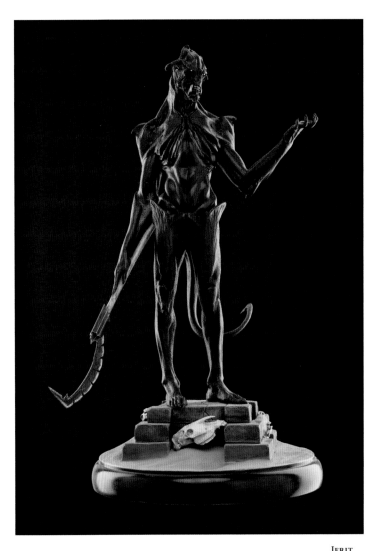

IFRIT
Richard Taylor/Weta Workshop
Resin moulded from Chavant 2006
Photography by Steve Unwin

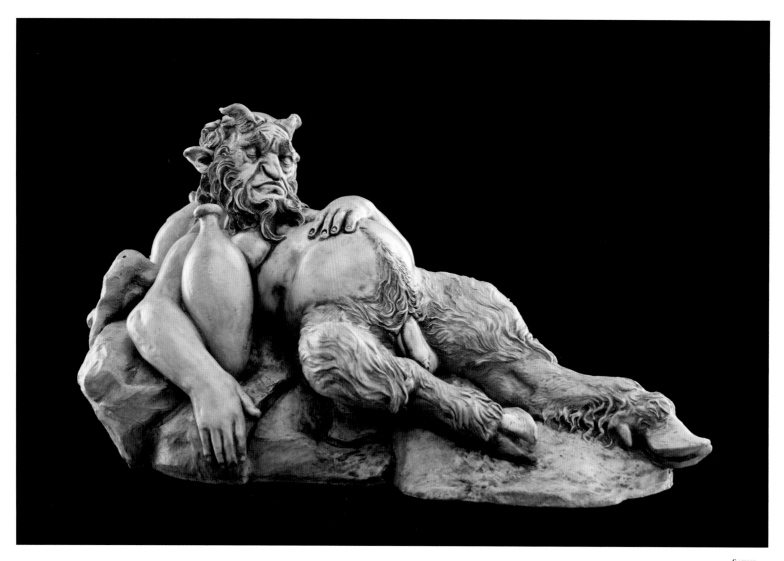

SATYR
Bronze moulded from Chavant 2007
Photography by Steve Unwin

Terrakula is a repurposing of the Latin word *terricula*, which means something that causes fear. In reappropriating the name I tried to give it a slight Romanian bent and create an original breed of demonic nuisance.

The ifrit is based on a belief in Islamic mythology in the jinn — the ifrit being a powerful fire entity.

The gargoyle was an attempt at a small cast bronze grotesque. This one's made of bronze — yes, real bronze! Wow!

I was trying to push myself to go for more rounded forms with the satyr sculpture, trying to emulate a classical feel.

STEPHEN LAMBERT

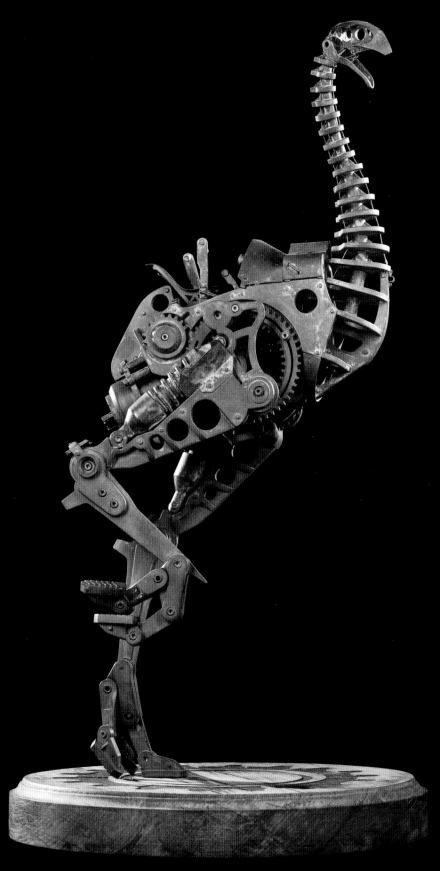

M.O.A.-bot (Mobilised Ornithological Automaton) aka 'The Ride-on Moa'
steel and brass 2008–9
Photograph by Steve Curtis

The works featured here belong to the worst client I have ever had the joy of trying to please — me. They are part of a series combining Aotearoa's giant creatures with a pseudo-steam-punk-Kiwiana-World War Two-era twist!

I came to this style through a love of all things mechanical and technical. But sculpture is something I fell into by a series of happy accidents. I had always envisioned that I would be an illustrator until someone suggested that I might enjoy animation. Since then I have more or less completely transplanted my workflow into the digital world to create new characters and bring them to life.

One brief for a sculpture later, and I rediscovered my interest in designing and building my own creations in the real world. As a kid I loved assembling things (my dad would say *dis*assembling them) and building models.

My conceptual design work and animation background has had a huge influence on how I approach my sculptural designs. While I love the flexibility and unlimited potential of the digital world, I find the satisfaction of the physical hard to beat — the reality of a solid object, the smell of thinners, the heat of welding . . . the sensation of knuckle-skin being removed on a sander or of separating super-glued fingers with a scalpel (however, I'm still one of those people who find themselves searching for the CTRL+Z keys on the drawing paper).

Art, in particular sculpture and drawing, is a constant battle between my hands, the picture in my head, and life's other obligations such as the lawns that haven't been mown in five weeks!

A certain person of royal blood upon viewing M.O.A.-bot (otherwise known as 'The Ride-on Moa') when visiting Weta asked me, 'Er . . . Why?' I assuredly replied, 'Why not?'

www.scoobasteve.co.nz, steve@scoobasteve.co.nz

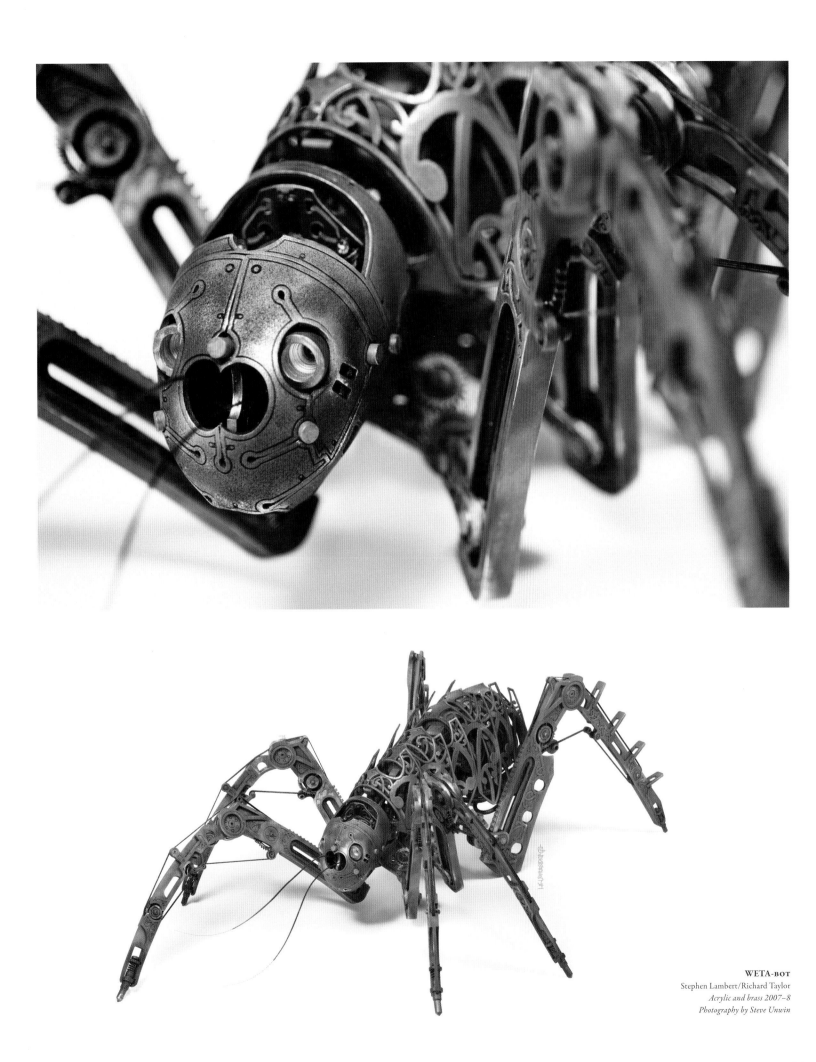

DAVID MENG

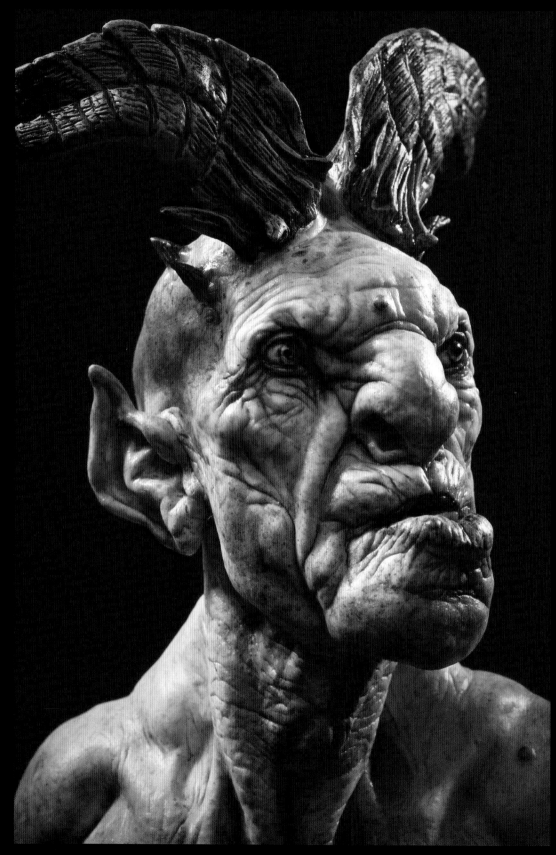

I have no hobbies or life whatsoever; creating creatures is my one single passion. I feel very lucky to be able to share it with a wider audience through this wonderful book.

One frustrating thing is that, as a sculptor, it takes so much *longer* to produce truly finished personal work outside my main job than if I were a 2D artist. Although I can draw and paint, I think my stronger arm is still sculpting, and I have only created a handful of personal work in the last few years. A regrettable fact when you look at the amount of stuff 2D artists can spin out in just a matter of weeks.

I want to start with some explanation of 'Man with Dogs'. This was a piece I originally created for Weta Workshop. It's my only piece in this book that was created for a client, although the circumstances were unique. Richard Taylor had given a few of us the chance to create original artwork. We were given complete freedom to do whatever we wanted, and were not required to present preliminary sketches. It was great fun. The dogs came out of a drawing I did in college, inspired by the Hans Christian Andersen fairy tale *The Tinder Box*, in which there is a character known as 'the dog with eyes as big as saucers'. The dog in the foreground was conceived as a foil to *The Tinder Box*-inspired dog cowering in the background, hence his lack of eyes entirely. I updated the piece last year with resculpts of the dogs, and changed the base.

ORANGUTAN OUTLAW
Pencil and digital 2007

RED MEAT
Pencil and digital 2006

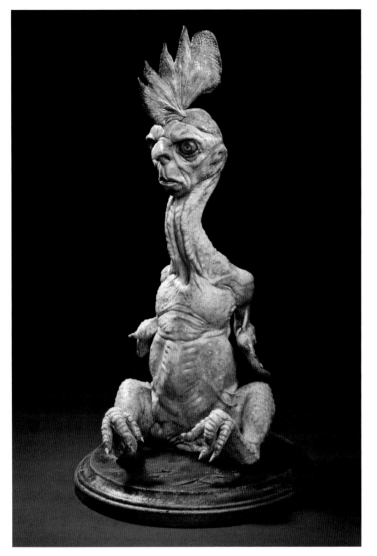

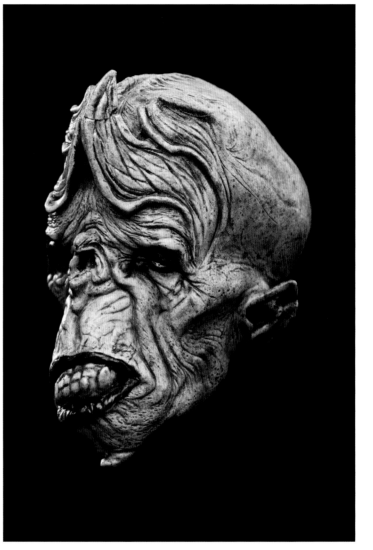

DER HUHNERMENSCH
Polymer clay 2008

JOHNNY SATAN PANTS
Painted polymer clay 2007

'Der Huhnermensch' is a piece I'm proud of, because I mostly succeeded in simulating plucked chicken skin! My reference came from the grocery store. After taking many close-up photos of greasy poultry meat, I had a lovely meal. This is the first in a series of pieces I want to do where beauty is explored in the grotesque or unpleasant. Looking at the photos I took of the actual dead bird, there were all these beautiful, delicate rainbow washes of blue, green, yellow and red underneath the pimpled skin. The subtlety of colours and the wealth and range of texture in the skin was incredible to look at. I think I managed to capture some of that in the model. The use of German for the title was a nod to Heinrich Kley, a pen-and-ink cartoonist who drew grotesque chimeras during the 1910s and 1920s.

'The Cellar God' is my newest sculpture. It gives the strongest indication of where my personal art is headed next. I have always been unhappy that many of my creatures are obvious

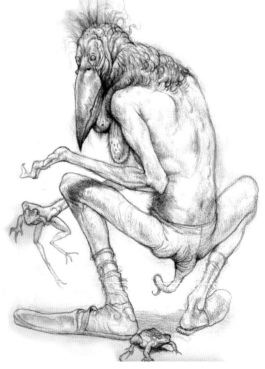

DEMON
Pencil 2005

human/animal hybrids, and have wanted to explore something more esoteric. The Cellar God itself, the white figure with the crested head, is an example of a possible solution to this. It's not easy to place exactly what animals, if any, it is derived from. The thing it rides is definitely crab-like, yet, then again, not entirely. It is an alchemical creation, part animal, part furniture, part vehicle. I tried to mix different lifeforms, influences, cultures and genres to create something different. Calling the piece 'The Cellar God' was part of the fun. It's great to add a layer of enigma over an already strange thing. A 'god' does not have to be anthropomorphic or dignified; it can be *anything*. And that's where I want the future course of my work to go, where *anything* can be conjured up.

www.davidmengart.blogspot.com
mengdavid.2010@gmail.com

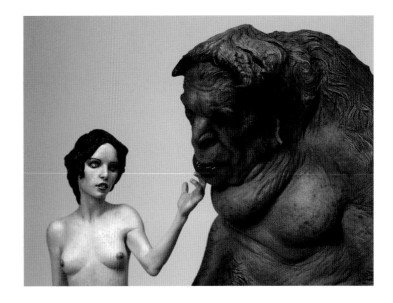

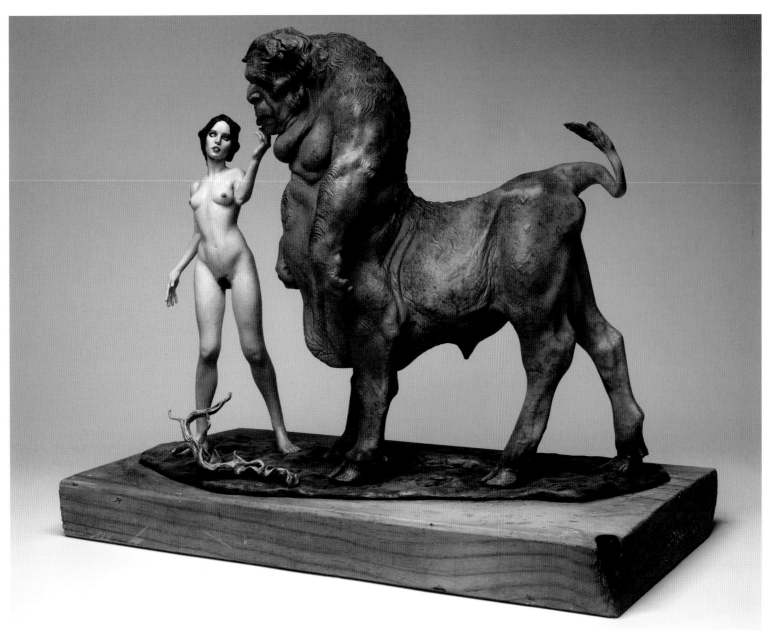

BULLY
Painted resin 2007

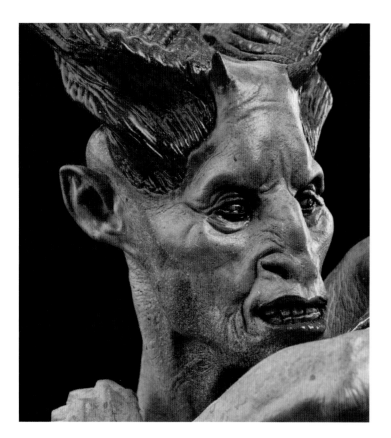

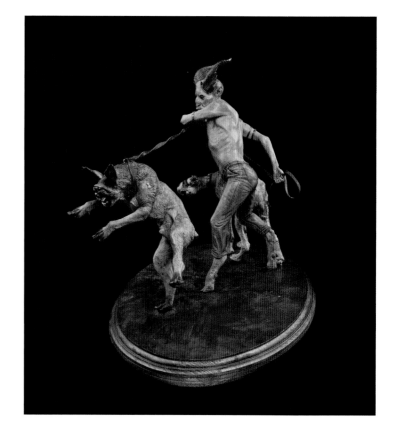

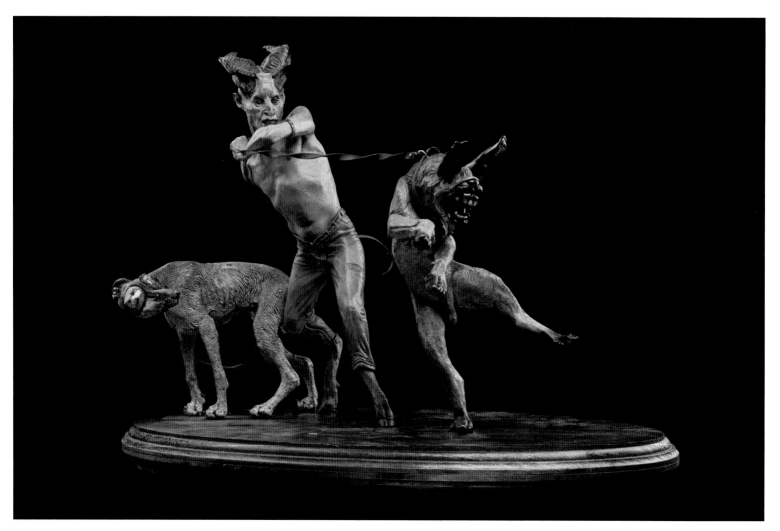

DAVID MENG

MAN WITH DOGS
Richard Taylor/Weta Workshop
Resin 2005, revisions made 2009
Photography by Steve Unwin

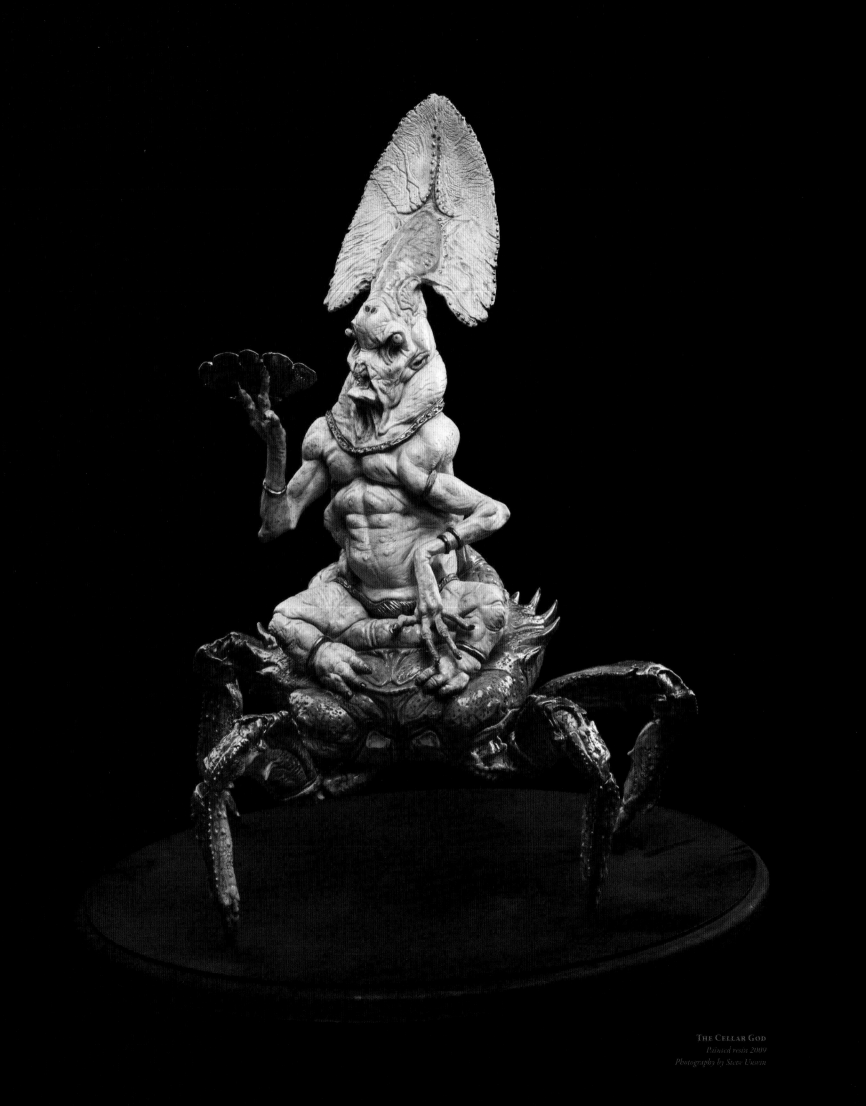

THE CELLAR GOD
Painted resin 2009
Photography by Steve Unwin

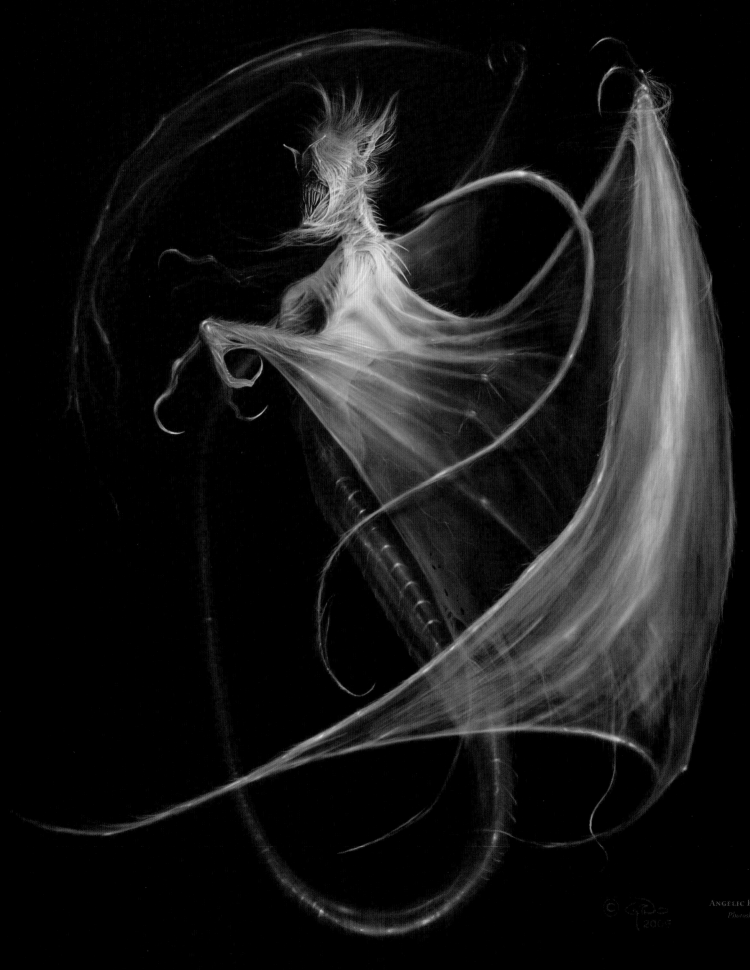

I grew up in Phoenix, Arizona in the United States. As far back as I can remember, I had a passion for drawing and creating monsters. Every Saturday morning I would watch a programme on TV called *World Beyond*, where I would get to see my favourite monster movies like *Frankenstein*, *The Wolf Man* and *Creature from the Black Lagoon*!

When I was eighteen years old, I started to work at a Halloween company designing and making Halloween masks. Through this company, I met a make-up artist from Los Angeles who took me under his wing and introduced me to the crazy movie world of Hollywood. After a few years with the company, I finally decided to pack my bags and move there. Through this connection I was able to meet make-up artist legends like Rick Baker, John Chambers and Dick Smith. I lived in LA for over fifteen years, working on some of Hollywood's biggest films.

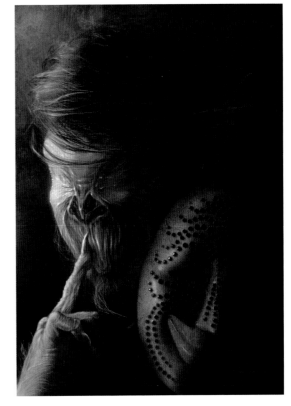

SURPRISE GUEST
Photoshop 2009

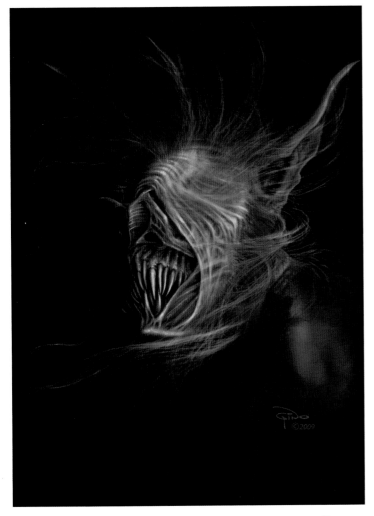

REAPER
Photoshop 2009

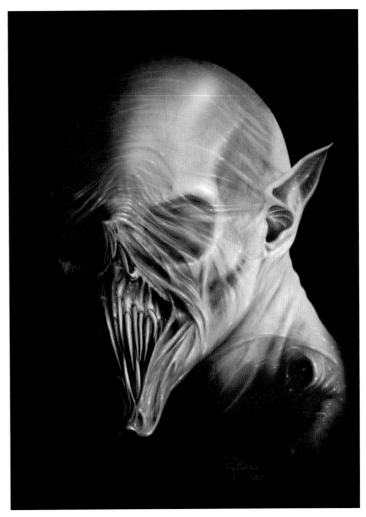

VAMPIRE
Photoshop 2009

Then, one day, while working for a friend's effects company called KNB Effects, co-owner Howard Berger said he had friends coming over from New Zealand who wanted to meet me and see my portfolio. This was of course Richard Taylor and Tania Rodger of Weta Workshop. They asked me if I would be interested in coming to work with them on a remake of *King Kong*, to design the colour schemes for Kong and the dinosaurs. Of course I jumped at the chance, even though I was a bit uncertain of just where this 'New Zealand' was! A few weeks later, I received a phone call from Richard saying that the project

had fallen over, but they would still like me to come out to work on another project which of course was *The Lord of the Rings*. I came out to supervise the make-up effects and to also design the colour schemes of the creatures of Middle-Earth.

After being in New Zealand for some time and having fallen in love with all that the country had to offer, I decided to make New Zealand my permanent home. I live in Wellington with my beautiful wife Liz and our adorable little girl Ruby.

arizonakiwi.64@gmail.com

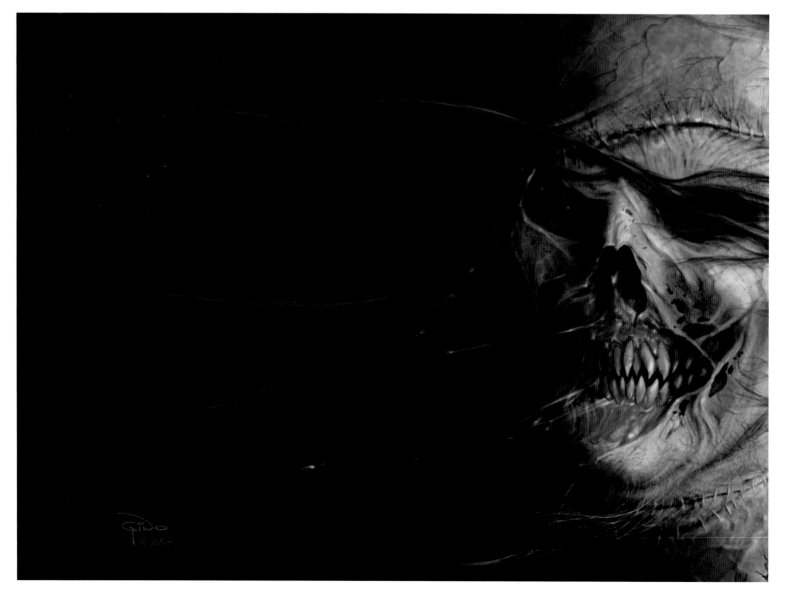

ZOMBIE
Photoshop 2009

GINO ACEVEDO

BEN STENBECK

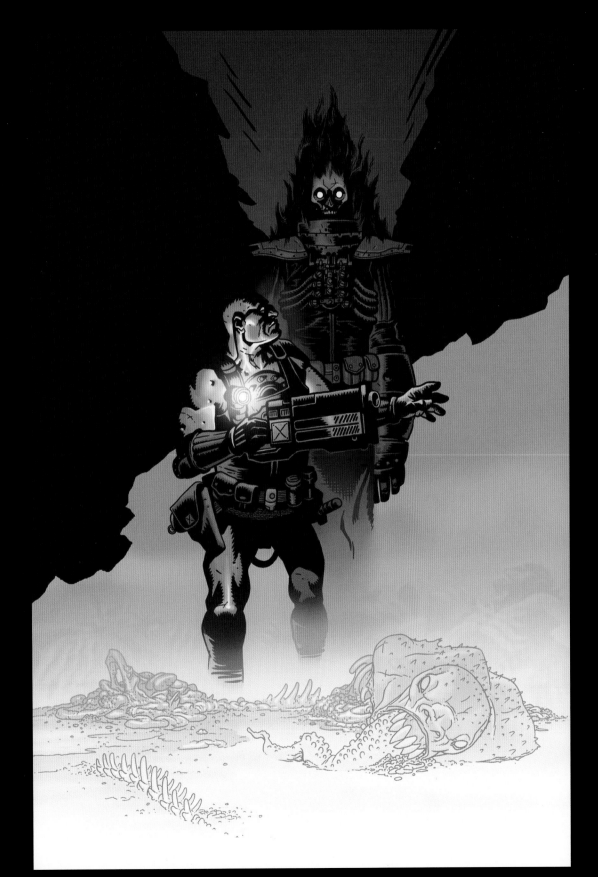

BLACK FLAME AND ROGER
Darkhorse Comics B.P.R.D.™ & Mike Mignola
Pencil and ink 2005

When I was six years old, I walked into a dairy in Paihia with one dollar in my grubby little hand and there in front of me was a mountain of comics. All unorganized, just stacked there. I sorted through them one after another, looking for something that was special enough to deserve a whole dollar. Then I came across a copy of *Judge Dredd*. In the first two pages I saw Judge Dredd shoot up a gang of gorillas wearing sunglasses and tam-o'-shanter hats. For the next thirty or so pages this comic blends together elements of horror, sci-fi and spaghetti westerns. I was plunged into a world that I could almost smell. Admittedly it wasn't a pleasant smell — there was some pretty gory stuff in there for a six year old. But in the back of my mind was a vague understanding that someone (in this case a few someones) had made it; that out of a person's head had come this dense, fleshy, dusty reality, and I had it in my hands. For a dollar!

So that's what I decided to do with my life. I've tried a few other mediums and industries, but drawing comics has always been the job I wanted to do.

Who wants to hear about how I work? You do? OK . . . I get a script. It gives a description of what the writer wants. In the case of someone like Mike Mignola, he may have specific story-telling things he wants to see or he might want designs to look a specific way, but most of the time it's pretty much left to the artist. I read through the script once or twice without drawing anything. Then I read it again, scribbling little notes, designs

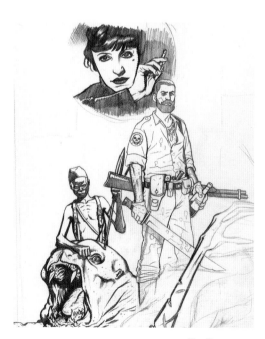

THE KAPTAIN
Pencil 2002

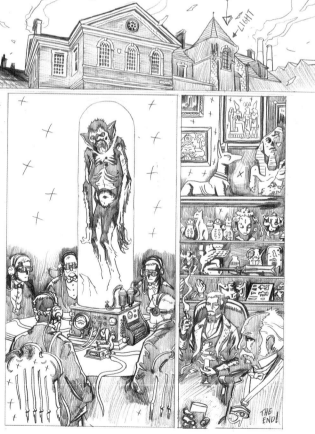

WITCHFINDER #5, PAGE 22, DARKHORSE COMICS
Witchfinder™ © 2010 Mike Mignola
Pencil 2009

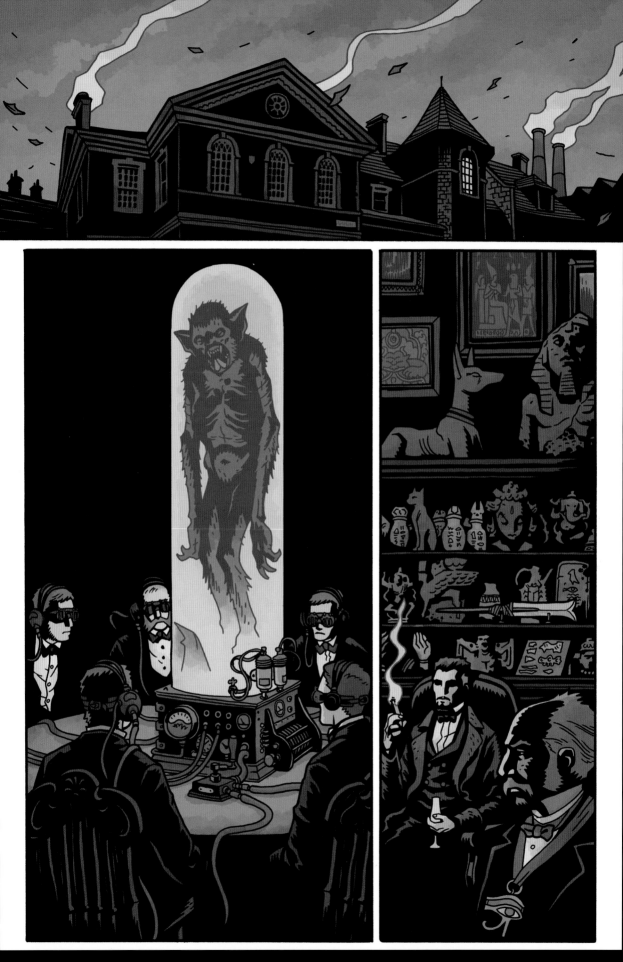

and layouts, in the margin. Then I move on to full layouts, which are small quick drawings of what the final page will look like. Those layouts are sent to the editor and he comes back to me with any changes he wants to the storytelling. That's really where all the nit-picking goes, in getting the storytelling to work from

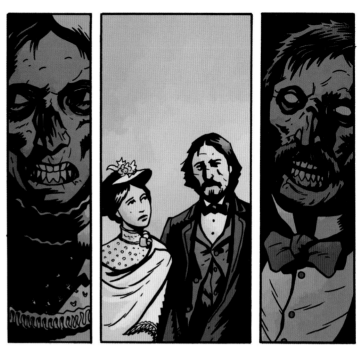

WITCHFINDER #3, PAGE 7, DARKHORSE COMICS
Witchfinder™ © 2010, Mike Mignola
Pencil and ink 2009, colours by Dave Stewart

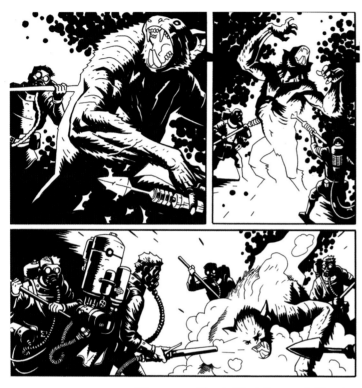

WITCHFINDER #4, PAGE 6 INKS, DARKHORSE COMICS
Witchfinder™ © 2010 Mike Mignola
Pencil and ink 2009

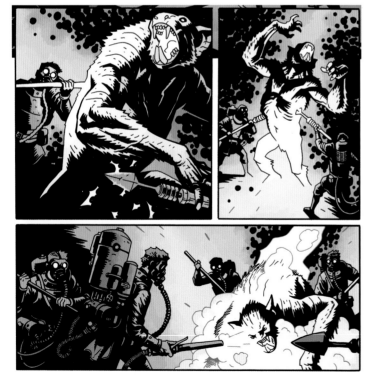

WITCHFINDER #4, PAGE 6, DARKHORSE COMICS
Witchfinder™ © 2010 Mike Mignola
Pencil and ink 2009, colours by Dave Stewart

the start. Then I go on to pencilling the whole thing, which for something like *Witchfinder* involves a ton of research. I tend to redraw things a lot, so most of my time is spent redrawing something I've already done over a lightbox. At my worst I've redrawn some panels eight or ten times. When that's done, it goes back to the editor, and there might be a few minor changes here or there. Then I ink it all — that's making the pencil bits black, with pens and whatnot. Then it gets coloured, in this case by the best guy in the business, Dave Stewart. The pages here are printed unlettered but the final step is to have all the dialogue added by a letterer. It takes me ten months to draw a five-issue series. That's ten months without a break or being able to stop thinking, 'I need to be faster, oh man, oh man, I'm a week behind, I suck, I can't draw, I'm going to get fired,' etc. etc.

This zombie stuff was done for the game 'Left 4 Dead' by Valve software. I'm not sure if anything I did made it into the final game, but it was fun to do. The paintings here were simple pencil-line drawings that I scanned and painted in Photoshop. I added a layer of dark colour over the line drawing and erased highlights from that to give me a sort of tonal under-painting. Then I painted it. I sometimes paint in the Quickmask feature to give me little patches of light or shadow that I can control with the brightness/contrast adjustment. Or you can work that way to adjust patches of colour. Everyone works in a slightly different way; I don't think it matters how you do it, you just have to find the way that works for you.

www.benstenbeck.com

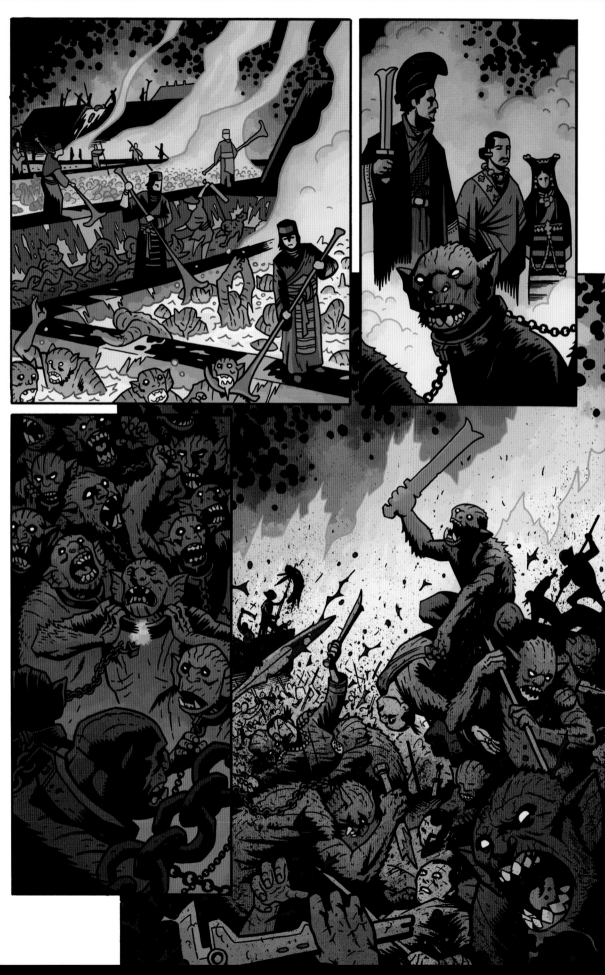

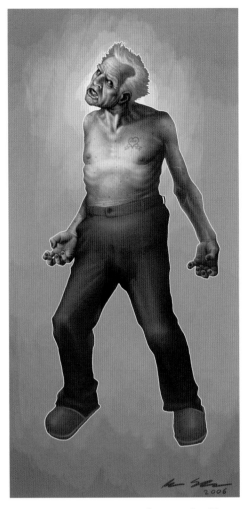

INFECTED OLD MAN
© Valve Corporation, image used with permission
Pencil and Photoshop 2006

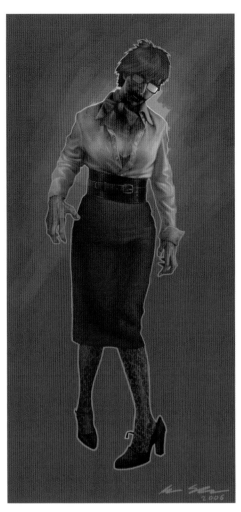

INFECTED SECRETARY
© Valve Corporation, image used with permission
Pencil and Photoshop 2006

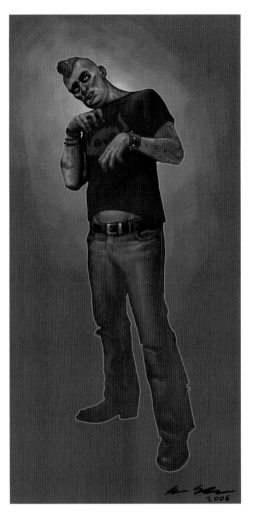

INFECTED PUNK GUY
© Valve Corporation, image used with permission
Pencil and Photoshop 2006

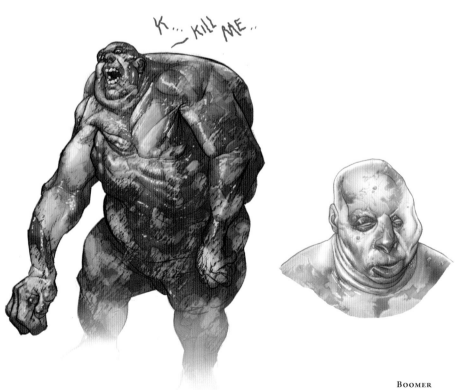

K... KILL ME..

BOOMER
© Valve Corporation, image used with permission
Pencil and Photoshop 2006

BEN STENBECK

SIMON MORSE

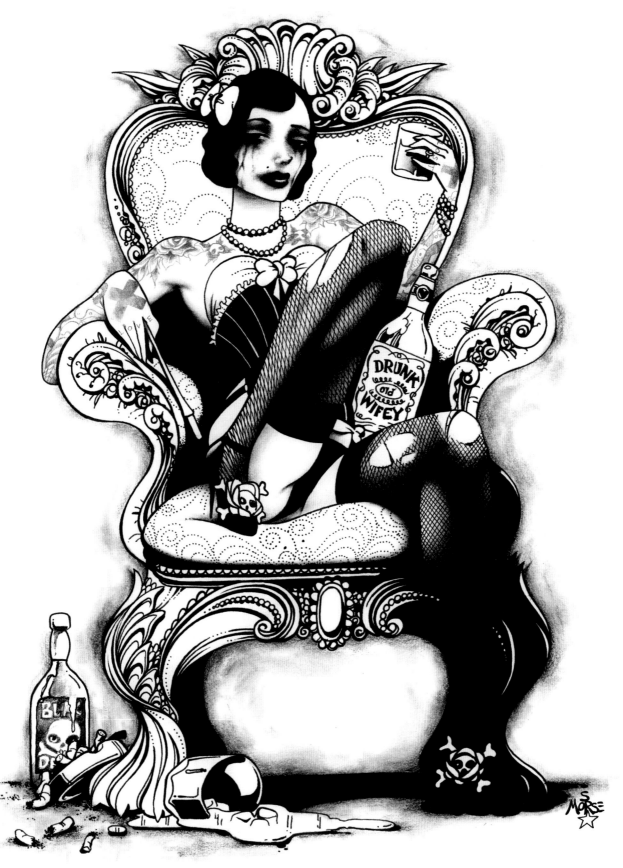

DRUNK WIFEY
ALC Apparel
Pencil and ink 2007

Whether it was my mother's Meatloaf album cover or my father's art and architecture books, pictures and picture books have always been overwhelmingly magical to me. I can't remember a time when the excitement of drawing has not been part of my life. When I was young, hours spent daydreaming of other worlds and translating those thoughts onto paper quickly became an obsession. I spent most of my school lunch-breaks in the classroom drawing epic robot battles or prehistoric landscapes while my classmates were out playing bullrush in the playground.

The discovery of comic books blew my mind completely. The concept of a story told through pictures became an addictive form of entertainment for me. Being transported into beautifully drawn pages became a 'fix' I just had to have every week. Imitating favourite drawings and artists seemed a natural way to spend my time. This was the beginning of my desire to become a comic-book artist.

My first venture into the art world, at the age of nineteen, happened when I self-published a photocopied fanzine called *Pistake* with artist Rufus Dayglo and writer David Tulloch. One particular strip in *Pistake* proved popular here in Aotearoa — a ninja parody story called *Straitjacket Ninja*. David was responsible for the witty text that I put pictures to. Readers' positive response to *Pistake* boosted my skills and confidence levels — high enough for me to decide to showcase my art in the USA.

In 1995 my studio buddy in New Zealand was the extremely talented artist Martin Emond. His *White Trash* comic had been accepted by Kevin Eastman for publication so Marty suggested I go to Massachusetts and show *Straitjacket Ninja* to Kevin, which I did. Kevin is co-creator of *Teenage Mutant Ninja Turtles* and he loved the ninja-parody angle in *Straitjacket Ninja* and gave me a regular slot in his comics anthology, *Death Rattle.*

David and I have recently resurrected *Straitjacket Ninja*, so keep an eye out in the comic shops!

Martin then came over to the USA too and introduced me to Glenn Danzig of Misfits and Danzig fame. Glenn was also publishing erotic horror comics under the Verotik label.

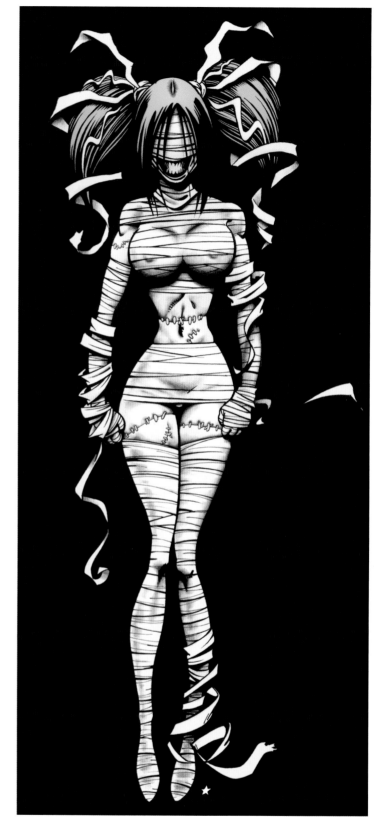

YUMMY MUMMY
Illicit Clothing
Pencil, ink and Photoshop 2004

He offered me a job drawing a story about a zombie hooker called *Grub Girl*. It was exciting working with huge talents such as Martin, Simon Bisley, Eric Canette and the legendary Frank Frazetta.

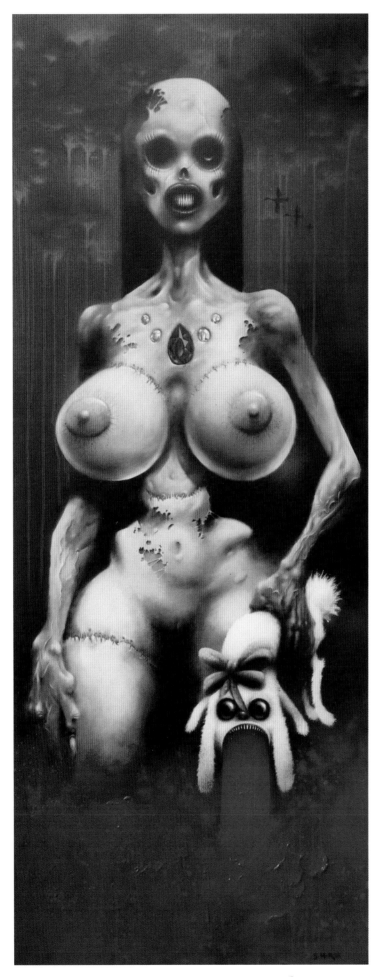

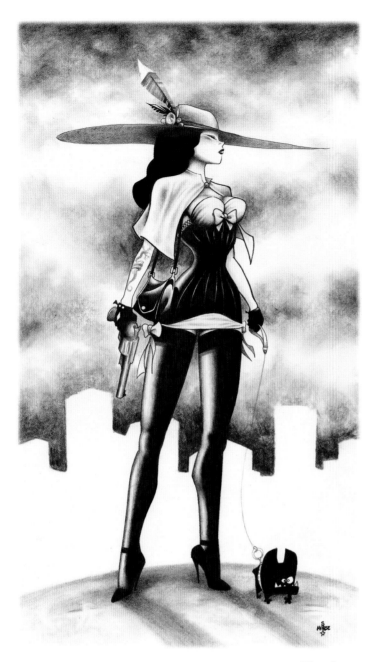

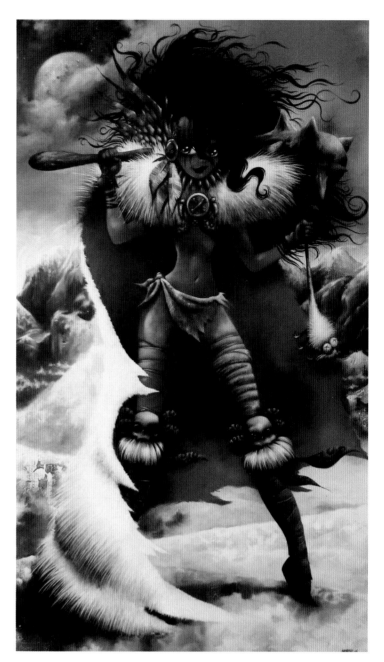

I HATE GUNS
Minuit
Pencil and ink 2007

CAVE GIRL
Plum
Acrylic on canvas 2006

When Martin and I returned to New Zealand, we relocated our studio and started working for model, sculpting and toy magazines in Japan called *DDD* and *Massive Action Figure*. Through this work, I created the half-woman/half-machine comic characters Toolbox and Chopper Chick.

After I'd shared studios with Marty for about ten years, he moved to Los Angeles to further pursue his art career. While in LA, he sadly took his own life in 2004. It was around that time I gave up on my comic career and it was almost the end of my art career, too.

After a good ten years of slaving over comic pages, and a year or two of limbo after the loss of Marty, I decided to focus on illustration. I love how I can put the same amount of effort into one illustration as I used to put into a ten-panel comic page. The amount of images on one comic page can become draining and it's a huge discipline. Putting the same amount of work into one piece is much more satisfying.

Comic books were a fantastic way to hone my drawing skills. I managed to perfect a great solid ink-line style during those comic-book years. I was extremely fortunate to have Martin

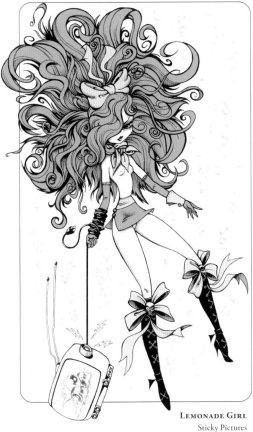

LEMONADE GIRL
Sticky Pictures
Pencil, ink and Photoshop 2006

around to teach me how to paint. Painting all those comic covers meant I already had my technique down when I branched out into a painting career. For my painted works, I use the same technique whether it's a tiny piece that measures a few inches or a six-foot canvas. It's basically a matter of applying copious amounts of thin washes until the pigments become solid enough for the image to create an illusion of form. I also attack my paintings with a spraycan and airbrush. My background in painting has been extremely helpful for using Photoshop but I still prefer to work with actual paint or pencil and ink because I feel physical artwork has a soul that digital work can lack. There is a time for digital — and that's when you're doing commercial jobs.

I have taken up tattooing in the past year and I believe it's good for artists to keep trying new mediums and tools. Personally, I can become bored with my art if I'm using the same style or technique for too long. Tattooing is a great way to combine the disciplined line work from my comic experience and my painting skills. I am tattooing at ALC Apparel in Wellington, the company I also design T-shirts for.

I might feel differently in another fifteen years, but right now I am excited about this tattooing venture.

www.simonmorse.co.nz

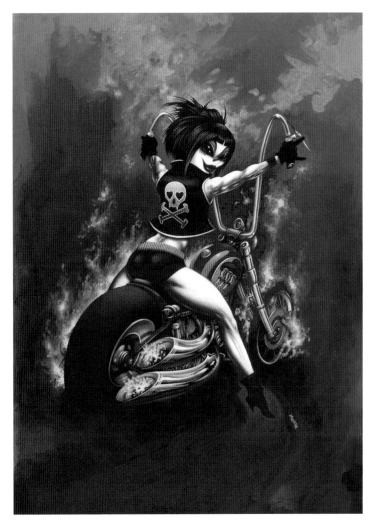

CHOPPER CHICK
DDD, Japan
Acrylic on board 2004

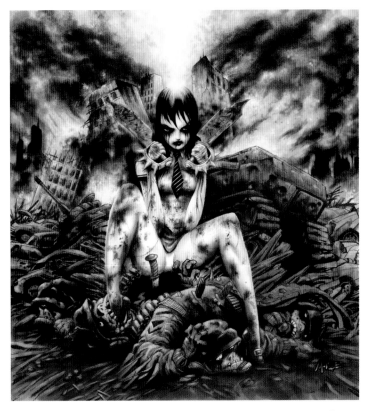

MASSIVE ACTION DESTROY GIRL
TGS
Pencil and Photoshop 2008

DYLAN COBURN

Art is what I've always done. Drawing is the first thing I remember doing and, aside from writing these words, it's also the last. Since the beginning my goal has been to 'give life' to my artwork, so naturally it's organic subject matter that interests me most. Animation means 'to give life', so when I was introduced to animation it quickly became an obsession that lasts to this day. Like most artists I know, I thoroughly respect the power and intricate mechanics of nature. If Leonardo were alive today he would be an animator. I'm sure of it.

Having worked professionally as an animator, illustrator and director for fifteen years, I find myself needing a good reason to pick up a pencil and draw. Why am I creating art? A good reason to create art is to illustrate a great story. In centuries past, the stories told in the Bible gave countless reasons to create art, and in the twenty-first century we have many more stories to choose from. I believe artists are the same creatures they've always been:

obsessive, compulsive, excitable, depressive and, last but not least, storytellers.

So, first I must have a reason to create art, either someone else's story or my own. If I'm working professionally and working with someone else's story, then I must understand the 'nature' of the work. Who is the writer? If it's a film, who is the director? They *will* have a vision, and I need to know it. Then it's my job to 'plus' that vision, and blast the project through its creative boundaries and realize its full potential visually.

The best advice I can give aspiring artists is to trust in the creative process — just *do* and great things will happen. It's like improvised poetry. It's like going for a fast run in a new town, ducking and weaving through streets, never considering where you're actually going. Most of the time you'll end up in exciting and interesting places. Sometimes you'll end up somewhere that's utterly horrible. Maybe horrible is good? Now you're on the right track.

www.dylancoburn.com, dylancoburn@me.com

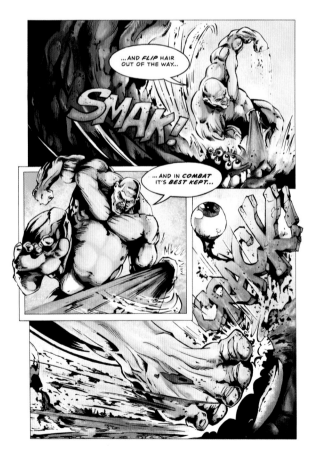

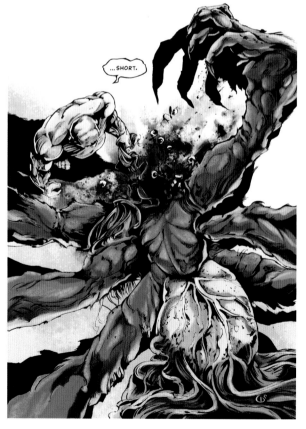

BABYMAN'S BIG DAY
Karactaz Limited
Ink and digital watercolour 2007

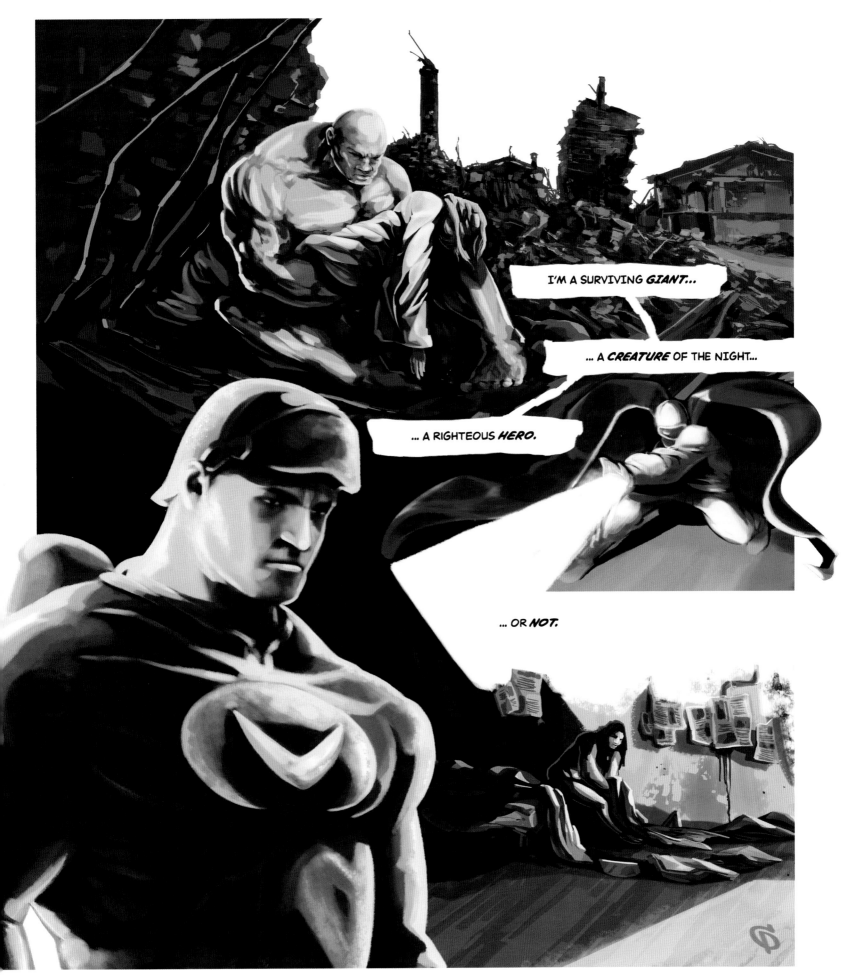

MAYBE NOT
Karactaz Limited
Digital paint 2009

CLAIRE HACKETT

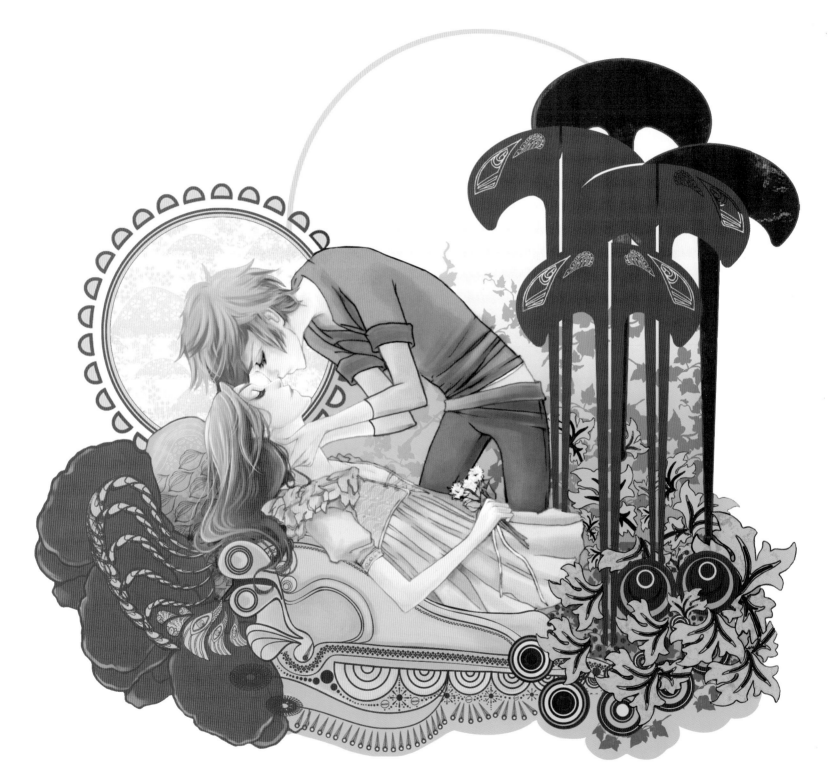

SLEEPING BEAUTY
Photoshop and Illustrator 2010

When I was younger, I would draw on anything I could get my hands on. Envelopes, paper bags, tissue, napkins — anything. Even books weren't safe from the permanent tattoo of my felts, crayons or whatever I happened to have in my hand at the time.

Usually, I decorated with gaudy, lacy doodles of ballerinas and the occasional mermaid; all sporting the same squashed, pudding-like faces, bulbous, two-fingered pincer hands and legs like inflatable chopsticks. I had no idea of style, shape or refinement — it was more as if I was challenging the illustrations on the page, trying to fit in, to enter their world and become part of the story.

At the time I had no idea how important creating worlds and telling stories would become to me, but I could appreciate the sense of magic and wonder that make-believe brought me. The ideas were there, the spark was there and it was incredibly addictive. Later my addiction was fuelled by my brothers' interest in RPG games, a very patient high-school art teacher and my own blossoming interest in comic books. I continued on a rough and bumpy trip of hard practice, limitless counts of personal breakdowns and a bathful of *Eureka*s before my characters stopped looking like some by-product of congenital disorder. Now they have become strange, angular, androgynous beings who can fit in anywhere and become anything. They can take a story and tell it in their own way, whether I feel like sharing a truth or an idea, or simply want to create something appealing to woo the spectator. I've still got so much to learn, but I love it — I crave it.

And I still draw ballerinas and mermaids.

chackettout.blogspot.com, chackettout@gmail.com

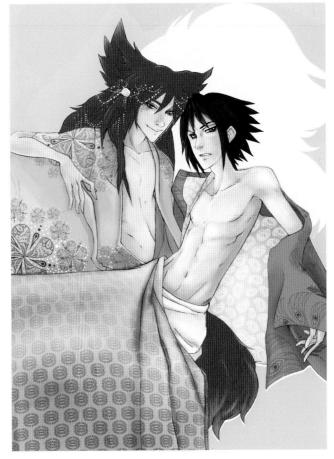

KITSUNE
Photoshop 2008

LITTLE BOY BLUE
Photoshop 2009

FREELOADER
Commission; *Photoshop 2008*

(following) **BEAUTY AND THE BEAST**
Photoshop 2010

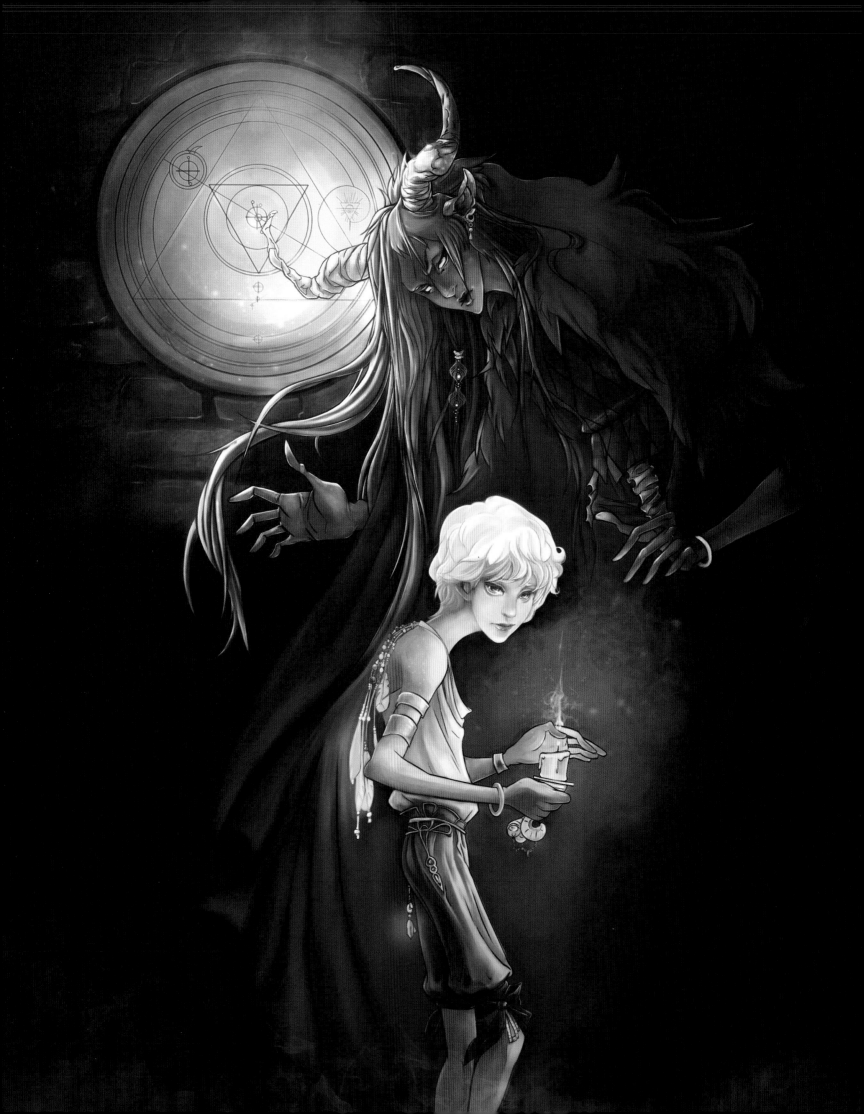

STEPHEN CROWE

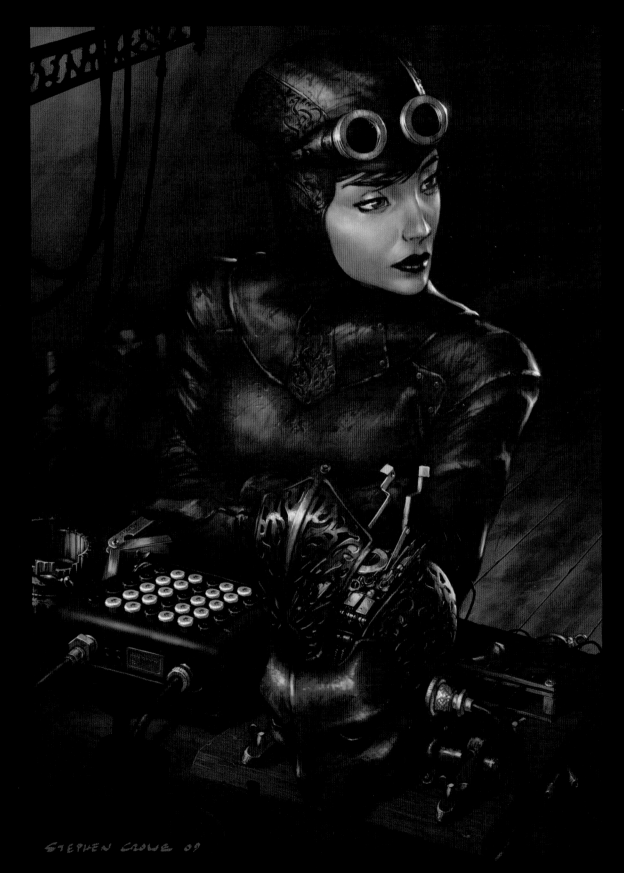

Stephen Crowe 09

Engineer
Photoshop 2009

The crowd in the busy dockside marketplace parts as the tall, skittish beast and its rider push their way through. Although the mounted figure is shrouded in ornate robes, it is immediately obvious to the market-goers that it is not one of them. The shape suggested by the fall of heavy drapery is wrong — large, and oddly proportioned. It takes a moment or two longer for them to recognize the haughty individual for what it is — Chéneschal, aloof and exotic.

It is shocking to see this enigmatic being here, now, moving amongst the bustle and clamour of an otherwise typical morning. Exhibiting a fearless curiosity that borders on aggression, the Chéneschal urges its mount through the thronging crowd, expecting a path to be cleared for it, which indeed it is. Only a slow-moving automaton, itself something of a curiosity in this part of town, fails to sense that it is in the path of beast and rider. At the last moment the robot's somewhat limited calculation core interprets the shadow falling across it as a possible point of danger. Instructing its metal limbs to shift it out of harm's way, the machine manages to escape with only a hefty nudge from the beast's flank.

ENGINEER SKETCHES
Pencil 2009

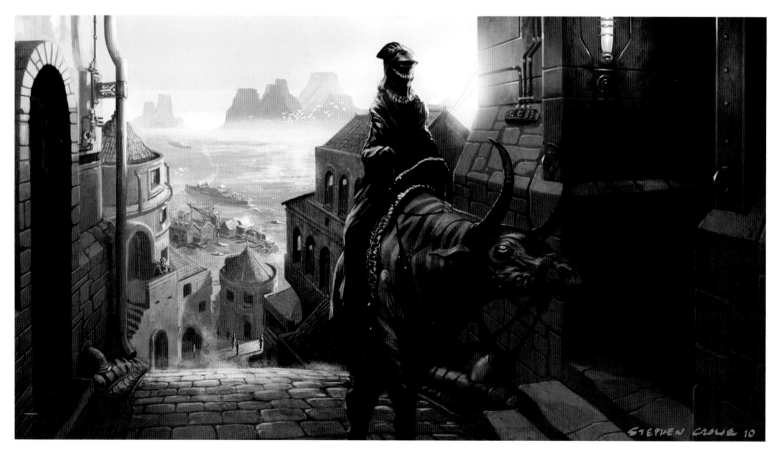

MORNING VISITOR
Photoshop 2010

STEPHEN CROWE

SPECIAL HAUL
Photoshop 2009

Correcting and maintaining its balance (a state which is in constant flux at the best of times), it ambles off on some pre-determined errand, already having forgotten its brush with the exotic.

The crowds thin, and the open spaces of the marketplace divide into narrow cobbled streets that climb steeply from the docks, as the Chéneschal rider follows its course through unfamiliar, alien territory. The buildings here crowd the streets, the rustic iron and stone façades on one side newly warmed by the still-rising sun, on the other, cool and dew dampened, but gleaming softly in reflected light.

The exotic mount is startled by a noisy, combustion-engined vehicle rattling its way through an intersection. Then it is gone; revealing, across the way, a cylindrical building of three stories, built, like most of its neighbours, from stone and iron. It is to this building that the Chéneschal directs the capricious beast, halting it by a very large, heavily built door; its gentle curve matching that of the building's façade. Sliding easily from the saddle, the robed figure unfastens a small, ornate club from its belt and raps firmly on the metallic surface.

INGHRAM SKETCHES
Pencil 2009

(following) **INGHRAM'S APPROACH**
Photoshop 2009

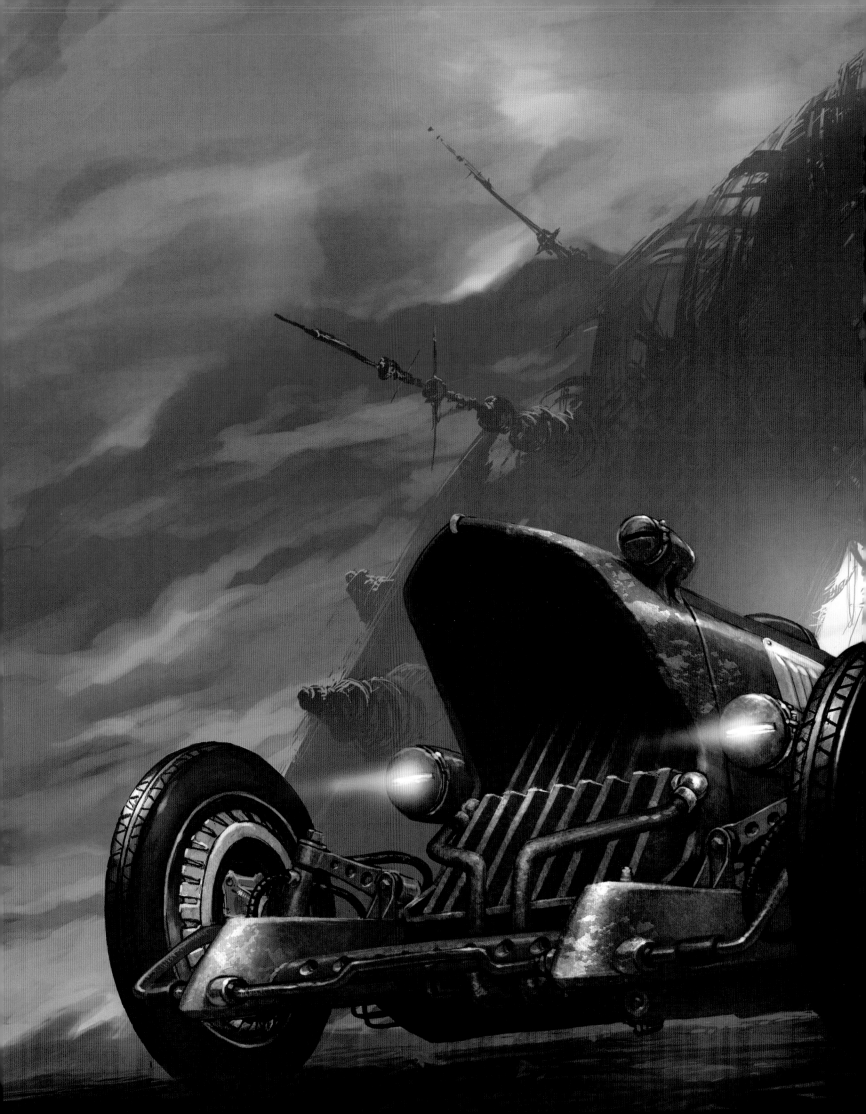

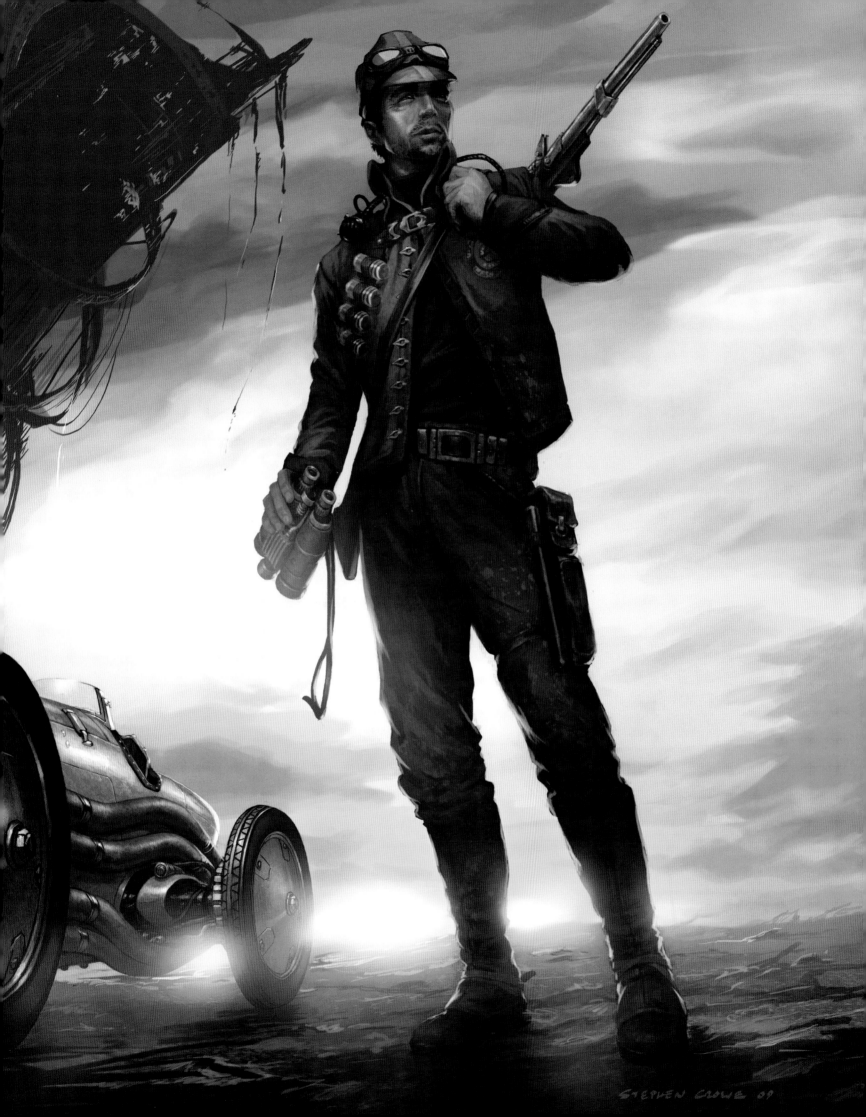

The Chéneschal is silent and still as it waits, while behind it the impatient beast snorts and stamps on the cobbles, eager to be moving again in this place of noise and strange scents.

At last, a smaller opening within the main door slides and clanks aside, revealing a darkened space within. A figure appears, leaning forward into the sunlight that is just now pushing a line of shadow down the metallic wall. She is pulling oil-stained leather gloves from her hands, and squinting up at the strange silhouette before her. Her initial look of surprise deepens as the Chéneschal bows its head, speaking a few words in its native tongue, and hands her a sealed envelope: an invitation.

So begins the story that has been slowly forming in my head, on paper, and in pixels over a period of about four years now. A forming of a world that has, by necessity, progressed in fits and starts: creation, squeezed into the few gaps left by the practical realities of a busy, modern life.

An engineer, renowned for designing and building exquisite robots. Trying to live her life in a world now ruled by an increasingly totalitarian leader; invited to travel to the mysterious island inhabited for centuries by a marooned off-world race, who are in need of the engineer's particular talents . . .

A royalist movement that searches for surviving members of the murdered monarchy, now forced underground by the martial brand of law enforced by the Lider Maximum's police.

A royal guardsman, prepared to sacrifice everything for redemption. And a chance to tip the balance in a battle that will either free their home from the grips of a bloodthirsty tyrant or bring a whole world to its knees.

How far would you go to save your king?

www.stephencroweillustration.com

Victori and Chéneschal Sketches
Pencil 2009

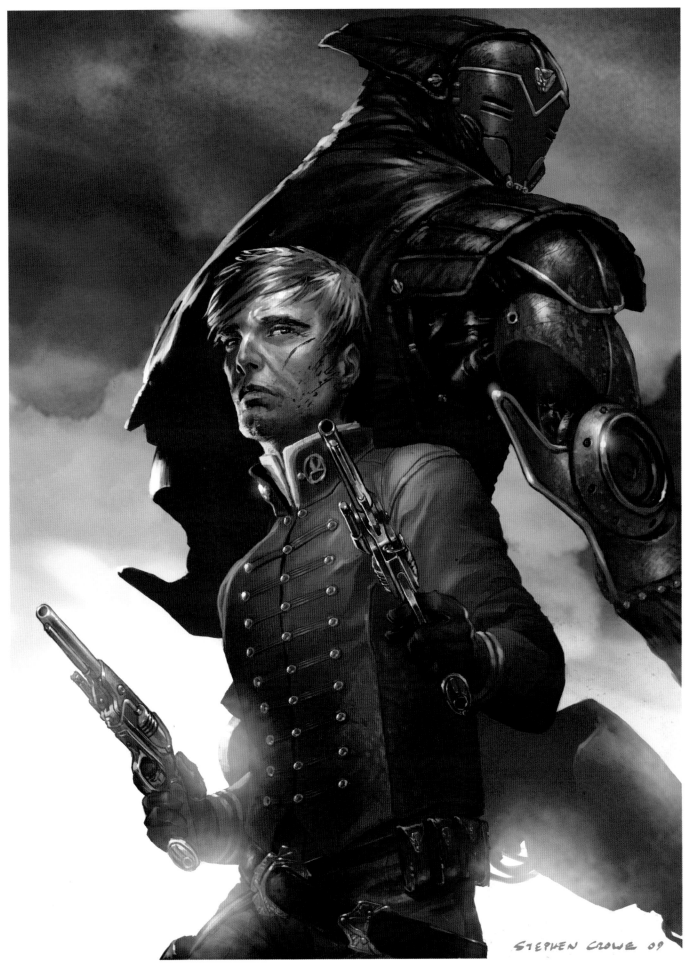

VICTORI AND ASH
Photoshop 2009

STEPHEN CROWE

113

THOMAS SIMPSON

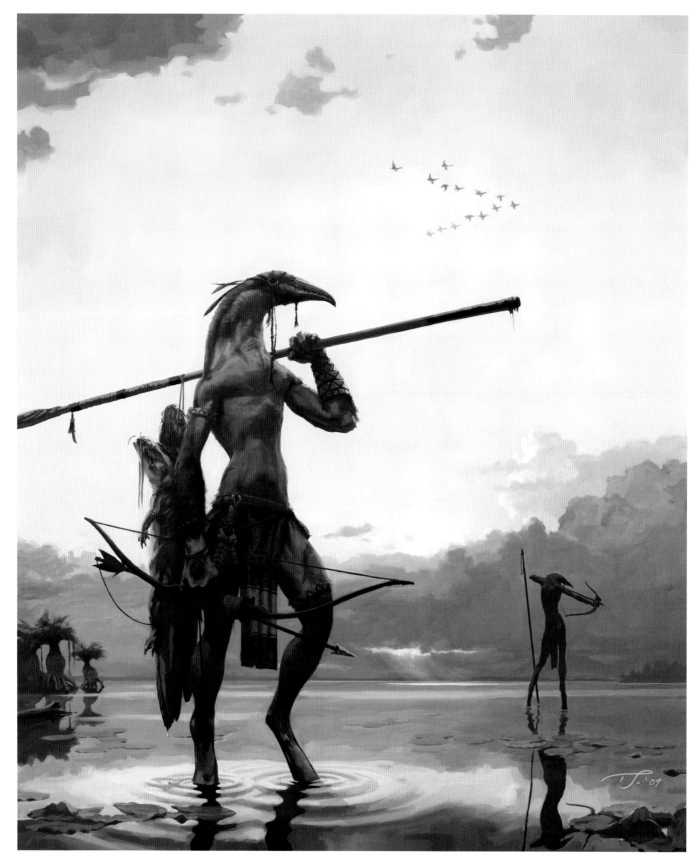

MARSHWALKERS
Corel Painter IX, 2009
After 'The Hunter' by N.C. Wyeth

For me, the process of creating art brings with it a sense of discovery. It is both a means of responding to the world around me, and of exploring the depths of my own imagination. Because of this, my work is often a fusion of what I am able to observe from life, and what I am able to imagine. I believe that it is important for artists to constantly observe the world in which we live, to help inform their own visions and convey them effectively to others.

Growing up on a farm in rural North Otago opened my eyes to a wealth of inspiration in my early years. My time spent exploring the landscape fuelled my imagination as a kid who loved to draw. This love of drawing grew during primary school, with the encouragement and guidance of local artist Burns Pollock. A fantastic mentor, Burns imparted to me many pearls of wisdom on the subject of art, and would send me home from his studio with arms full of books to pore over. It was in the pages of these books that I first saw paintings by such artists as N.C. Wyeth, Norman Rockwell and Edward Hopper, whose work would have such a lasting influence on me. Even now, almost twenty years later, a visit to Burns' studio guarantees a stack of books for me to lug home.

Creatures, plants and environments, both real and imagined, are frequent subjects in my images. This stems from my fascination with the natural world and the mind-blowing diversity which it is host to. I also draw inspiration from innumerable other sources: from music, to mythology, to simply taking a walk down the street.

Art (and in particular 'fantasy art') is often associated with escapism: the desire to step outside one's own reality. Far more important than this, however, is the power of art to enrich our own reality: to shake us out of our patterns of perception and make us take notice of things we may see every day but fail to fully appreciate. The role of the artist, at least in part, is to remind people just how fascinating the world around us is, and how fortunate we are to be part of its fabric.

www.artoftomsimpson.com

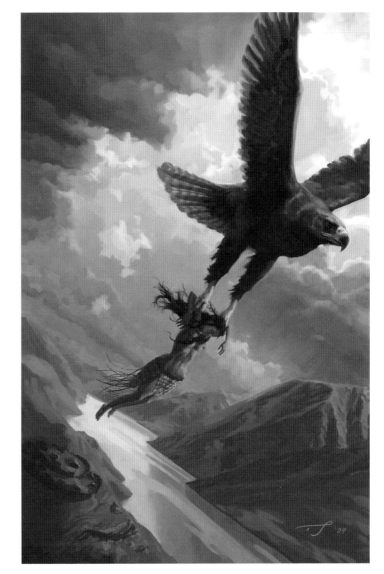

HOKIOI
Corel Painter IX, 2009

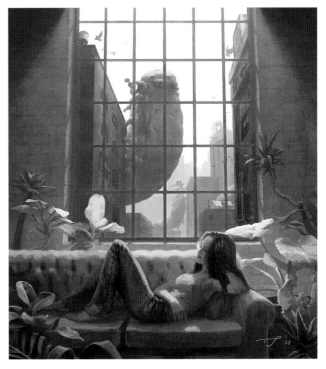

THE GREEN ROOM
Corel Painter IX and Photoshop 2008

MATTY RODGERS

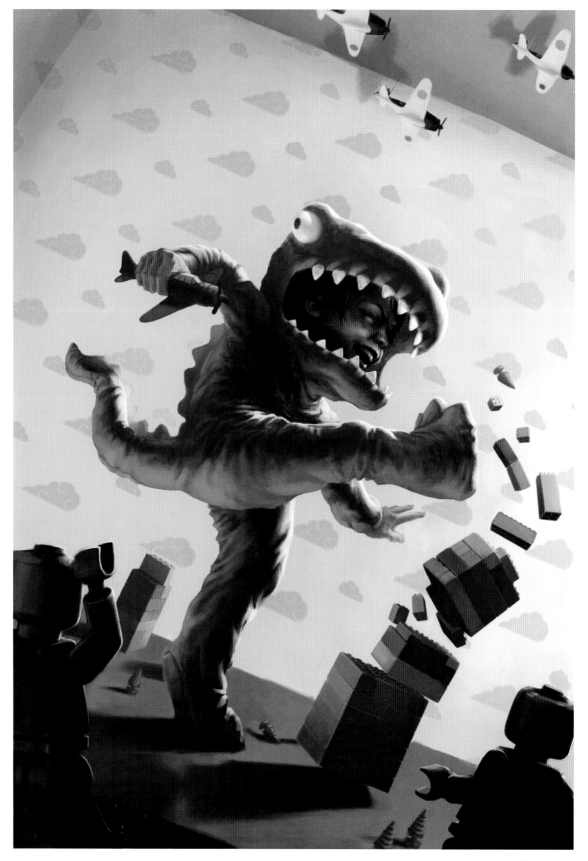

KIDZILLA
Digital 2009

I've always loved to draw and paint, but never really considered art as a career choice. Then one day in a first-year computer science lecture, I noticed that my pad contained vastly more drawings than notes, and I finally realized I couldn't consider anything else.

I moved to Wellington to study design, and there I met the people that would help me and join me on my journey of appreciating beauty. That is what an artist does, I think. We nurture a childlike curiosity in an effort to see the world as if for the first time. Through these eyes we study the world and let its beauty infuse the works we create.

I love to draw and paint from life and then take those observations and use them to lend credibility to my more fantastical ideas. While those ideas range from dark confrontations to celebrations of youthful exuberance, I always try to inject as much life into them as possible. I'm naturally attracted to figurative work with dynamic poses, skewed camera angles and high-contrast lighting.

Right now I am lucky enough to spend my days at Weta Workshop doing concept design for film. In my spare time I create limited-edition fine-art prints which are a kind of playful counterpoint to the often sinister things we draw at work.

www.cavematty.com

COWARDLY LION
Pencil and digital 2008

SPIDER GIRL
Pencil and digital 2008

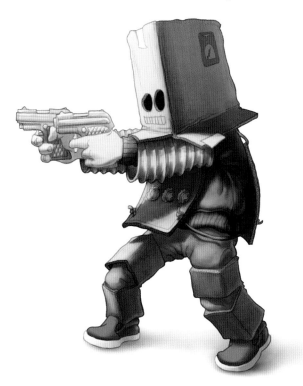

ROBOT BOY
Pencil and digital 2008

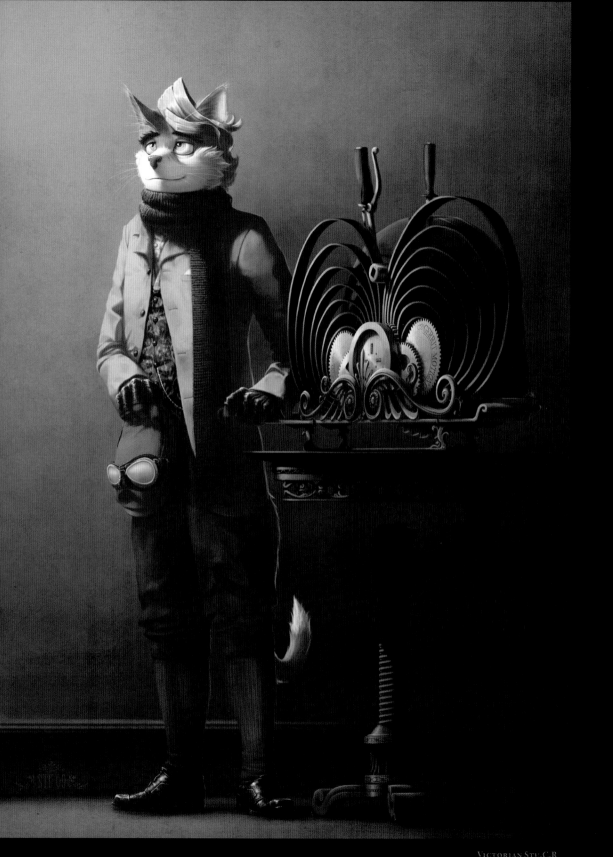

Born in Singapore in 1982, I got exported to a place called 'The Naki' at the age of three.

In the year 2000 I was given the amazing gift of the Internet and got into sketching anthropomorphic characters after stumbling across Jeff Axer's sweet art. Intrigued by his detail, I thought it would be fun to give this drawing thing a dangle and began creating simple characters based on myself and my mates.

During university, I continued to draw and develop these characters into their own personalities, when I wasn't playing Return to Castle Wolfenstein. An extra year of uni was completed to take a digital illustration paper that forced me to use a tablet, and learn about this digital painting biz. I am currently working at Weta Workshop as a concept artist, and surrounded by the raddest team on this giant fish.

The cat featured here is one of my earliest characters that was based on me, but he rides around on a modified V-twin circular saw as a form of transportation that would never work. Though in a cartoon world where the rules of physics are flipped the bird, it looks mean as with all those sparks.

www.office11.co.nz, romancepie.blogspot.com, stu@office11.co.nz

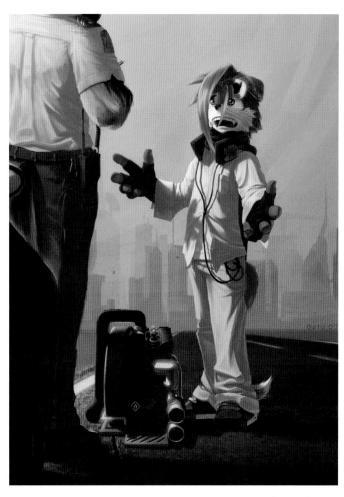

PULLED OVER
Photoshop 2007

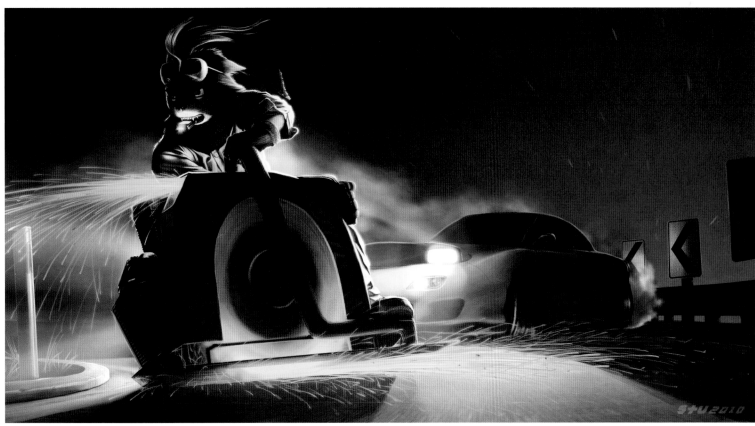

SAW DRIFT
Photoshop 2010

STUART THOMAS

119

FRANK VICTORIA

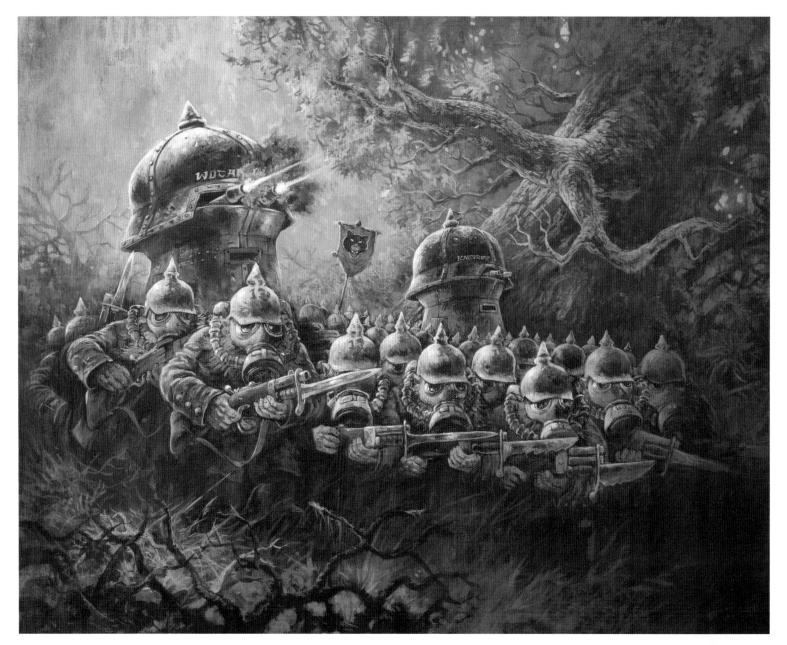

A few years ago, I received a letter from the French government informing me that a distant relative had died, and that I — as the closest living relation — would inherit all his worldly possessions. These were contained in a single box, now on its way to New Zealand.

Some time later, a big wooden box arrived in the post. It contained a leather-bound diary, several oil paintings and a collection of peculiar carvings, all dating back to the First World War. It had been in storage for many years; the only indication of its provenance was a stamp from the French army: 'Classified'.

Inside the box, I discovered a series of old newspapers dated 12 November 1918 — the day after the Great War ended. The front page contained the following main article:

Paradise in hell

At noon on the 11th of November 1918, after hostilities had ceased on the western front, British, German and French forces agreed to meet in

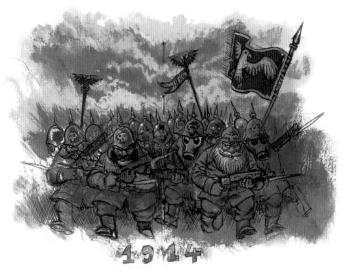

ORIGINAL SKETCH OF 'GAS ATTACK'
Pen and acrylic on paper 2005

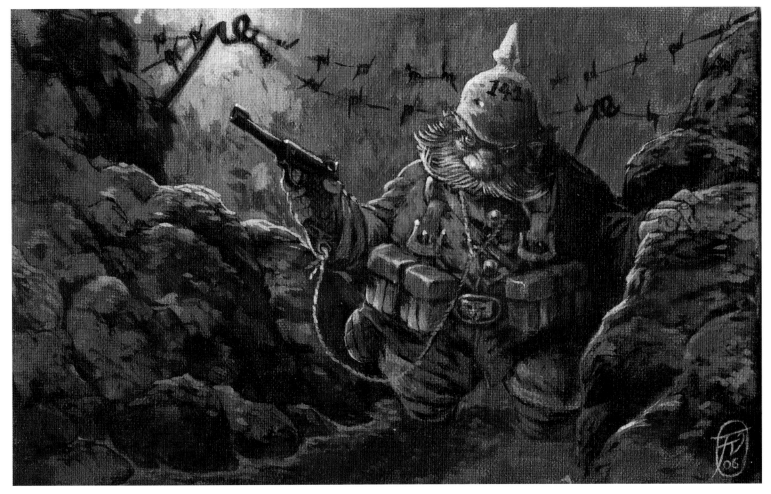

IN THE TRENCHES
Acrylic on canvas board 2006

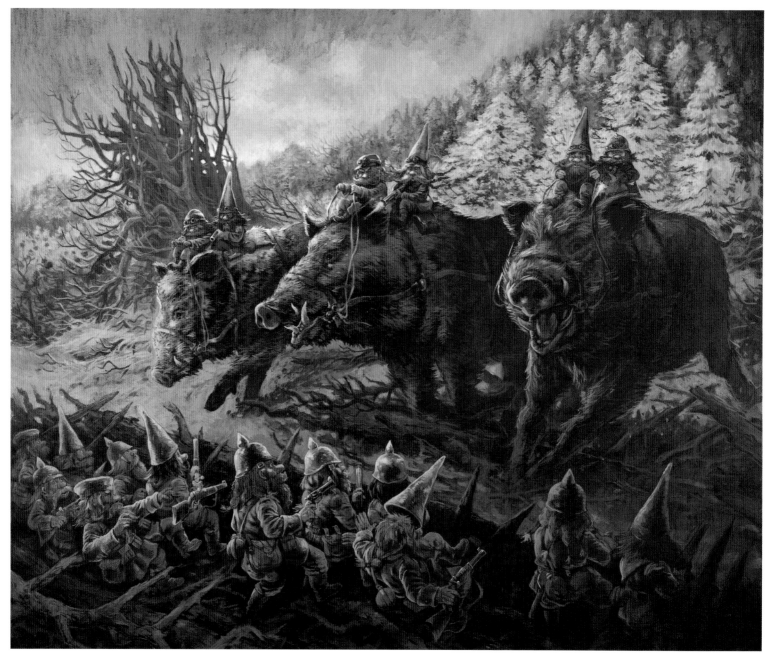

THE CHARGE
Acrylic on canvas board 2007

no-man's land. They chose a location in the Somme region, near a place named 'The Faerie Stone'. As they arrived amidst the devastation, they were surprised to see a circle of untouched forest. During four years of incessant bombardment, not one single shell had landed on this patch of green. In the forest the investigating officers found a ring of ancient stones, as well as the remains of a single infantryman. Underneath a dolmen, and surrounded by a number of undisclosed items, lay a dead German soldier, possibly of Alsatian origin. The reasons for his death, so far from the German lines where he would have been posted, were a mystery. It is unclear whether the soldier had lost his way, deserted, or been driven mad by shell shock.

MACHINE GUNNER OF THE BLUE BOAR EMPIRE
Acrylic and ink on paper 2006

A French army spokesman has declared that a full investigation will be conducted at a later date. As the soldier's identity has not yet been officially confirmed, his remains, as well as the objects found with him on site, are to be placed in the care of the French military.

Another article from the back page of a paper dated 21 March 1968 revived the story, favouring the idea that the man had simply gone crazy. The soldier, one Felix Volker, had apparently been found at rest beneath the dolmen, his bony fingers still clutching a journal filled with fantastical sketches. Entries about real events were mixed in with tales of magical Little People that only he could see. It was a sad story, asserted the article, and one far too common in the Great War.

LIGHT INFANTRY OF THE BLUE BOAR EMPIRE SPRING 1914
Acrylic and ink on paper 2007

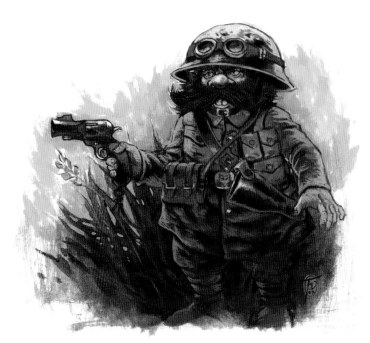

INFANTRYMAN OF THE RED FOX EMPIRE 1916
Acrylic on paper 2007

(following) **EXTRACT OF FELIX VOLKER'S JOURNAL**
Acrylic gouache and digital 2007

23 November

A war to end all wars, but only because we'll all be ~~dead~~
deaf by the time it's done!

"What's that you say, sir? Shelling again last night?
Wouldn't know, sir. I'm reading your lips now, sir."

Should write to Anne-Sophie, but haven't. What's to say?
"My darling, here's another sketch of the little fellow I saw
climb over the top of my bunker today.

Stood up there, seven inches proud, and surveyed
the whole valley like he owned it!
If he saw me, he didn't curl a red whisker.

bla bla
bla!

Shouted something to a companion below.
Tried to make a decent likeness,
but it's hard from memory"

Found another
little ~~shoe~~ too!
boot

24 November

<u>Shelling</u>. Can't think for shelling. Can't write for shelling. Can't breathe for shelling. Can't fart for shelling

25 November

Saw another one! Pops over the top of the lookout, bold as brass, while yours truly is having a well-earned smoke. Six inches tall, maybe more?

This time, he just sits himself down on a stone and takes out a dinky pipe-piece of his own.

No one else in hailing distance, and me thinking, that's it, I'm I've lost it!

So I do what any thinking man would do, confronted by his own ~~experience~~ mental disintegration:

I take out the sketch book, and ask the little fellow politely if I might take a likeness.

He assents, gentleman that he is.

The journal I received in the box was the journal of Felix Volker. In it, my long-lost uncle claims to have struck up a friendship with a dwarf, one of the tiny faerie folk of legend. As this relationship unfolds, Felix discovers to his bewilderment that even as Europe is torn to shreds about him, a war is also taking place in the faerie realm, mainly carried out by the dwarves and their allies. In a strange echo of human history, two empires, the 'Blue Boar' and the 'Red Fox', fight against a third, the 'Black Bear.'

I present the contents of his journal here without prejudice, or further commentary of my own. For there is no doubt that whether Felix Volker lost his mind or truly witnessed something extraordinary in the mud of the trenches, his experience was real to him, and evidently worth dying for.

frankvictoria-lepicte.blogspot.com

PILOT OF THE RED FOX EMPIRE
Acrylic and ink on paper 2006

Afterword by
Alan Lee and John Howe

'A picture is worth a thousand words.' Well, not always; in the film industry a few words in a script can generate hundreds of pictures before the process of filming starts. Most of these will be unseen except by colleagues and those interested enough to look through the 'Making of' or 'Art of' books that a successful film may generate. The artists involved are passionately and deeply involved with more than just the look of the film — the back stories, the history of the places and characters, the marvellous intricacies of detail — that part of the story-telling that is absorbed unnoticed and yet adds hugely to the audiences' enjoyment of, and belief in, the tales being told.

It's an exhaustive and exhausting process and the artists featured here have proved over and over again that they have the skills and imagination to match, complement and fulfil any director's vision . . . And they have their own stories to tell as well. Here is a collection — hopefully the first of many — of artworks representing the rich and diverse talents of some real movie heroes and heroines. Wonder and enjoy!

Alan Lee

Dryad
Paul Tobin
Pencil 2010

Dreams can be a hard slog. Daydreaming doesn't make them come true; they need working at, they need concentration and, more often than not, they require sacrifices.

It takes a spark. A conviction born of certainties untested, forever to be acquired and refined. It means harbouring a desire to tell stories, desire coupled with a certain initial awkwardness with words, and an ability to read and understand images.

To shield that spark on a blustery day, heading home in the dark after ten or more hours of intensely hard work, and then fan it back to incandescence bright enough to light work until midnight long gone takes a healthy dose of determination. Nevertheless, that is just what most of the artists in this book have done.

Many of those featured in this book have passed through the doors of Weta Workshop. The Workshop is a demanding place in which to work. Every ounce of creativity and energy is ground and wrung out of those who work there by the relentless and voracious movie-making machine. The Workshop expects nothing less; there's little space for almost good enough. But in return, it provides a safe haven for originality, a wealth of emulation and the virus of imagination.

Imagination is like a cold. It's contagious, but unlike a cold, you never really get over it. Once you've caught imagination, there is no cure; you just have to put up with the symptoms. Imagination strikes at the oddest times; it wakes a person up in the middle of the night to scribble ideas on scraps of paper or do sudden sketches in the margins of a paperback on the bus.

It's easy to come down with a serious case of imagination at Weta. (Close working conditions, environment contagiously inspirational, air thick with ideas . . .) That may explain why all the artists in this book have worked all day and then gone home to . . . work. Because participating in some of the world's grandest movie projects of the last decades is not *quite* enough. Some things simply really *need* one's signature in the corner, however modest an endeavour it may appear in comparison.

Artists are loners who enjoy company. Artists are people with skills they can hire out, but they are also people who are happy home alone, hunched over a watercolour, or staring intently at a canvas or a computer screen, lost in worlds of their own creating. Lost between the lines of stories they may well be telling without realizing it. Or not *just* quite yet.

Because that's the other thing about narrative imagery: each painting is a fragment of a story. An image contains not only what is explicit, but what is implicit, in equal measure. It contains the promise of what happened before and the premise of what will come. It can be heady stuff, not unlike running a bit of a temperature. And ideas just pour out so fast, a pencil can't keep up. It's all creativity and just plain elbow grease. Flights of fancy and pencil stubs. Software crashes, midnight coffees and the dreams one works hardest at, patiently building worlds of the mind. White Cloud Worlds.

You might be forgiven for thinking that Weta Workshop is the epicentre of fantasy art in New Zealand. It is, rather, just the visible tip of the iceberg. There is a lot of midnight oil being determinedly burned all over the country by passionate and independent souls who share the vision of worlds seen through the looking glass. Nearly half of this book is dedicated to their work.

You only have to set foot in Aotearoa to know that it is truly a special place. Tectonic plates bump and grind happily (and startlingly), earth meets the sea along some of the most astonishing coastlines in the world. The light is special: desert harshness tempered by ocean brume. Weather, straight from Antarctica at times, the kind that makes you clutch your hat, except it's already blown away. (Cloud-gazing in Wellington is like a day at the races.) The flora is special; curiously familiar landscapes hide unexpected details, a constancy of contradiction that is not far removed from the aspirations of fantasy. The fauna is directly descended from the denizens of Gondwana, marooned on two mini-continents drifting slowly eastwards in the South Pacific, nearly 1500 miles from its nearest antipodean neighbour. No wonder it was fated to become Middle-Earth.

New Zealanders often wistfully remark that they feel a bit far away from the world, that they regret not having history underfoot as Europeans do, castles on skylines, Roman roads and standing stones. Well, let them complain. They already have everything else; it just wouldn't be fair if they had that too.

John Howe